# On Racial Icons

# PINPOINTS

Pinpoints is a series of concise books created to explore complex topics by explaining key theories, current scholarship, and important concepts in a brief, accessible style. Each Pinpoints book, in under 100 pages, enables readers to gain a working knowledge of essential topics quickly.

Written by leading Rutgers University faculty, the books showcase preeminent scholars from the humanities, social sciences, or sciences. Pinpoints books provide readers with access to world-class teaching and research faculty and offer a window to a broad range of subjects, for a wide circle of scholars, students, and nonspecialist general readers.

Rutgers University Press, through its groundbreaking Pinpoints series, brings affordable and quality educational opportunities to readers worldwide.

The series comprises the following five volumes:

Deborah Carr, *Worried Sick: How Stress Hurts Us and How to Bounce Back*

Nicole R. Fleetwood, *On Racial Icons: Blackness and the Public Imagination*

James W. Hughes and Joseph J. Seneca, *New Jersey's Postsuburban Economy*

Toby C. Jones, *Running Dry: Essays on Water and Environmental Crisis*

Charles Keeton, *A Ray of Light in a Sea of Dark Matter*

# On Racial Icons

## BLACKNESS AND THE PUBLIC IMAGINATION

NICOLE R. FLEETWOOD

RUTGERS UNIVERSITY PRESS

*New Brunswick, New Jersey, and London*

Library of Congress Control Number: 2014959402

ISBN 978-0-8135-6515-6 (pbk.)—
ISBN 978-0-8135-6513-2 (ebook (Web PDF))—
ISBN 978-0-8135-7525-4 (ebook (ePub))

Visit our website: http://rutgerspress.rutgers.edu

Manufactured in the United States of America

*To every black child who aspires to be recognized and loved. My wish is that you never have to experience the moment when you learn that many will never recognize, accept, or love you because you are black. May your images be freed from the prism of racism. May you live in the radiance of love and acceptance.*

# Contents

# Illustrations

# Acknowledgments

I WOULD LIKE TO THANK Nancy Hewitt for inviting me to participate in Rutgers University Press's Pinpoints series. I am deeply appreciative of the kindness and patience of editor-in-chief Leslie Mitchner, who worked with me on this project. Thank you also to Marlie Wasserman and the rest of the team at Rutgers University Press. I offer my most heartfelt thanks to my dear friend and editor Ricardo Bracho, an incredibly talented playwright, brilliant intellectual, and deeply committed friend, who read this manuscript several times for me. Thank you to my research assistant Elix Colon for handling permissions and so much more. I have learned immeasurably from conversations and exchanges with Rich Blint, Daniel Carlton, Juliana Chang, Aimee Meredith Cox, Erica R. Edwards, Maco Faniel, Sherman Fleetwood Jr., Annie Fukushima, Michael Gillespie, Rebekah Hammonds, Allan Isaac, Arthur Jafa, Douglas Jones, Carol Joyce, Greg Tate, Celine Parreñas Shimizu, Lisa Thompson, Sarah Tobias, Deb Vargas, and Christian John Wikane and thank them for their suggestions and advice. A special thanks to Harry Langdon and Tracy Collins for their generosity and talent. I also want to thank the following for sharing their works with me:

Alex Abboud, Donna Austin, Bayeté Ross Smith, Jesse Drew, Michael W. Eaton, La'Trice Pew, Mark J. Sebastian, Benja Thomas, Stephanie Keith, the Dream Defenders, EPA, and the Art Institute of Chicago.

As always, my deepest thanks and love to my son, Kai Aubrey Fleetwood Greene, for his love, patience, and wonderful sense of humor.

*On Racial Icons*

# Introduction

FROM EARLY ON, I was aware that my experience of being a young black girl was one of living in relationship to images of blackness and black subjects that circulated broadly in the public sphere. As a child, I knew that I had no control over these images and how they were disseminated, but that many of my interactions in public spaces, with blacks and non-blacks, would be in conversation with these images. I also knew that those images, more often than not, presented a challenge to my existence, to being able to occupy space without expectation, deficit, or reaction. How did I know these things on such a guttural level as early as the third grade, in particular given that I grew up in a majority black neighborhood and went to a predominantly black elementary school?

*On Racial Icons* is a meditation on how we—as a broad American public—fixate on certain images of race and nation, specifically the black icon. In examining the significance of the racial icon to public life in the United States, the book attempts to understand the particular and peculiar relationship between the nation, representation, and race in the context of the history of U.S. slavery and the present of enduring racial inequality. To consider the racial icon as a negotiation of the historical present, the book focuses on the significance and valuation of key black political, social, and cultural figures and the meaning that the national public attaches to such icons.

My hope is that this inquiry provides an opportunity to think with readers about race, nation, and American public culture through photographic representation.

The book grows out of a rich body of scholarship, art, and criticism on race and visual culture. Much of this previous work examines and historicizes the production and meaning of visual images of black subjects within black communities and the nation-state. In such work, scholars have shown how the development and rise of popular and journalistic photography correlates to organized intellectual, cultural, and political movements of black Americans toward freedom, citizenship, and racial justice.[1] Important scholarship has also shown how black activists and artists have used image as a weapon to fight racial oppression. In the pages that follow, I offer various case studies of the making and circulation of racial icons, focusing primarily on the medium of photography, instead of a historical account of the racial icon. To engage with the diverse images in this study, I use interdisciplinary methods from the fields of visual culture, critical race and ethnic studies, and American studies. What this effort entails is a close focus on specific images, a concern about the conditions of production and the historical context out of which images emerge, and attention to the images' circulation and reception in the public sphere during different historical moments.

The images here that serve as the subject of our meditation are easily accessible in the public sphere: activism, political leadership, celebrity, and sports. They are familiar visuals to many in the United States, and members of a global media sphere have easy access. In this respect, these are "public images," meant for broad consumption. They might be found in newspapers, on billboards, in magazines and books, and on political posters and album covers. They might be used to promote a political, cultural, economic, or social agenda. Some are in the public domain and are repurposed for new audiences. Many

circulate virally through the Internet and social media sites. Access to such images changes, as does their production, consumption, and reception. These case studies—of photography, a medium known for its two-dimensionality and often characterized (disputably) by its stillness—unfold in a multi-textured arena where the racial icon is widely consumed in the midst of persistent, quotidian, and extreme racial inequality and suffering. And thus, the racial icon presents a challenge. Inasmuch as it stands for a marking of a democratic notion of racial trajectory, it continues to serve as a plea for recognition and justice for black Americans in light of historical and ongoing forms of racism.

Within the broad category of public images, I am interested in those that are normative to our understanding of race in the United States; these are images that have a common-sense meaning to them in terms of the national imaginary and a broad public's familiarity with them. They are interwoven into how a dominant, media-saturated American public understands race as interstitial to the formation of the nation. By American public, I do not mean to suggest that there is one definition of Americans or what constitutes the public. Instead, I use American public as a fraught concept, a necessary fiction of how various constituents, populations, and individuals make sense of the nation as a collective body.

The images chosen here are not simply supplements or illustrations of race but are part of the production and circulation of the racial narrative of this country. Thus visualizing is integral to narrating the nation. Images do not convey one single message, nor do they speak to one single, unified audience. The iconic images that I examine here as they relate to nation building and constituting an American public can be read and used for entirely different purposes. What might seem radical or anti-establishment in one era can be incorporated into dominant messages at another historical moment, and vice

versa. Regardless of whether images are used in ways that some consider regressive and others progressive, how do racial iconic images become part of the story that Americans tell each other and the world about the unfolding of nation and the possibility of democracy?

Partly, this question can be answered by considering the logic of "our" attachments to certain public images that have come to represent, symbolize, or substitute for a larger historical narrative of race and blackness in the United States. These images often carry a sort of public burden, in their attempts to transform the despised into the idolized. In their formal and symbolic characteristics of ideation, they work against the long and voluminous history of degrading racial caricatures. Such caricatures run the gamut from turn-of-the-twentieth-century pickaninny and Little Sambo postcards to hyperbolic violent and sexualized filmic representations (*The Birth of a Nation* as the quintessential film in such terrorizing image production) to more seemingly benign images of blacks as servants and caregivers to whites (that continue in contemporary popular culture with films like *The Help* and *Lee Daniel's The Butler*). As a counterbalance to intentionally demeaning characterization, racial icons can serve to uplift, literally and symbolically, "the black race" and the nation.

Racial icons, especially in the realm of social and political movements, make us want to *do* something. These images can impact us with such emotional force that we are compelled: to do, to feel, to see. While the affective responses (what one might call the impulse to act or the urgency expressed in some images) are familiar and rehearsed, our individual and collective actions are not predictable or easy to measure in any specific, linear, or causal way, as I discuss in chapter 1 through an examination of the motley and shifting sense of the collective and the divergent responses to Trayvon Martin's death. The large imprint of these emotional responses and collective

actions has to do with Martin's tragic death, and also his iconicization through visual production.

## ICON: THE VENERATION OF IMAGE

The history of the icon is long and complex. A term of divination, the icon is rooted in a desire to represent, and thus produce, God. There are many traditions (Byzantine, Russian, Eastern Orthodox, Coptic) of icons—paintings of religious figures—as sacred art that date back to early Christianity. In these contexts, the icon was not only a representation of the sacred but was itself a mode of prayer; a well-known example is the *Black Madonna of Częstochowa, Poland* (date unknown). This iconic painting is imbued with sacred power for its worshippers; every year tens of thousands of pilgrims come to behold the black Madonna and baby Jesus. While the painting is atypical in representing Mary and Jesus with darker skin (some believe due to candle residue, smoke, and flames over the course of its life), the painting is representative of the sacred art of icon painting in many other respects. Icons tend to be flat panel devotional paintings in which religious figures are represented to emphasize their holiness through symbols such as halos and color, where gold is representative of heaven and red of divine life. The features and poses of the religious figures are restrained and uniform to emphasize their transcendent, heavenly status.[2]

In *Black Madonna of Częstochowa*, Madonna gestures toward Jesus—the anticipated return of the Messiah, the Christian savior of humanity (see figure 1). We find this sort of anticipation and willful and devout hope in many contemporary renditions of the icon. Scholar Malgorzata Oleszkiewicz-Peralba analyzes how the Black Madonna icon of Poland and other parts of Europe and Latin America is a syncretic icon bringing together "Catholicism, Amerindian traditions, African orisa worship, and eastern and central European and Iberian cultures, as well

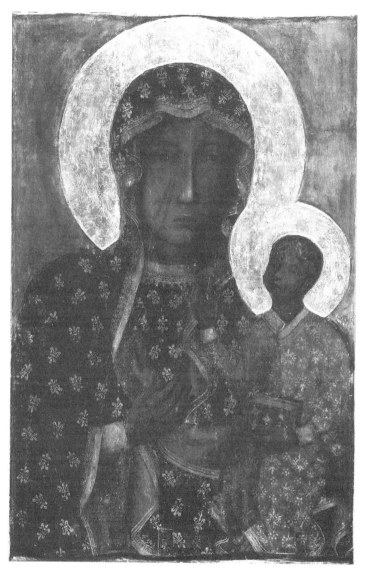

Figure 1. *Black Madonna of Częstochowa, Poland*, date unknown.

as the emergence of the 'great mother' figure in Latin America."[3] Moreover, she examines how this transatlantic icon represents resistance, empowerment, and a symbol of nation in different contexts.

The style of iconographic representation has evolved from its early Christian origins in religious painting, but across time, geographic region, and other boundaries, the icon continues to embody form as a sacred figure at the hand of the artist. Esteemed scholar and author of *Iconology* W. J. T. Mitchell writes, "The critical study of the icon begins with the idea that human beings are created 'in the image and likeness' of their creator and culminates, rather less grandly, in the modern science of 'image-making' in advertising and propaganda."[4]

To produce an icon, from the inception of the term in early Christianity, is to venerate. It is a mode of deification that involves finding the godlikeness in human form. Thus early on, icons were images of honor, treated with a great deal of respect and adoration. What accompanies the icon as an image of veneration is a deep suspicion of the image and practices of representation. In earlier times, the concern was idolatry—the worshipping of objects and images. In the contemporary era, the suspicion arises through fear of audience manipulation. The inherited tension between image worship and the condemnation of representation persists.

My framing of the icon shifts throughout the following pages, as it does in public culture. At moments, the icon connotes its commonsense usage: a notable public person who represents a set of attributes, traits, or talents valued by a given society. In popular culture, the icon often refers to a celebrity with staying power. In the arenas of politics and civil society, the icon tends to refer to a charismatic leader, a dedicated advocate, or a fearless trailblazer. In visual theory, the icon is an image, like a photographic representation, imbued with significant social and symbolic meaning, so much so that it needs

little explication for the cultural reader to decode it. The icon in contemporary culture carries multiple meanings, but I contend that there remains the trace of worship and that the icon continues to gesture toward the sacred.

While the icon carries the trace of godlikeness, to render a subject as black within various histories and discursive traditions means literally and symbolically to denigrate: to blacken, disparage, belittle. The verb *to denigrate*, with its Latin origins and roots in light/dark metaphors, means not only "to blacken" but also "to defame," "to discredit."[5] To denigrate is a castigation in which darkness is associated with incivility, evil, mystery, and the subhuman. Racial iconicity hinges on a relationship between veneration and denigration and this twinning shapes the visual production and reception of black American icons. The racial icon as both a venerated and denigrated figure serves a resonating function as a visual embodiment of American history and as proof of the supremacy of American democracy.

As much as possible, I stay away from specialized academic language, unless necessary. I use *society* to refer to U.S. society. I use *nation* to refer to the United States of America. Many scholars and cultural critics use concepts such as iconicity and iconography to talk about the processes and systems of iconic production more so than to refer to specific examples of iconic people or photographs. At times, I make reference to these specific theories. In the pages that follow I attempt to create a space for readers and myself to practice deceleration—a slowing down to allow for a type of contemplation that seems far too rare in our present moment. Art historian Jennifer Roberts describes deceleration as "a productive process, a form of skilled apprehension that can orient students in critical ways to the contemporary world."[6] Deceleration is a useful intervention in a culture that prides itself on speed and limitless distractions. The racial icon, in this context, provides opportunities for us to pause and consider image, race, and nation, as we

examine what images come to represent the nation in specific contexts. In so doing, I hope we gain more insight into what it means and feels like to belong, or not.

## THE PHOTOGRAPHIC ICON AND PUBLIC CULTURE

In their influential study *No Caption Needed: Iconic Photographs, Public Culture, and Liberal Democracy*, Robert Hariman and John Louis Lucaites define iconic photographs "as those photographic images appearing in print, electronic, or digital media that are widely recognized and remembered, are understood to be representations of historically significant events, activate strong emotional identification or response, and are reproduced across a range of media, genres, or topics."[7] Hariman and Lucaites examine how iconic photojournalistic images produce meaning about being a citizen, modern polity, and notions of the collective in "liberal-democratic public culture."[8] Their theory of iconic photography and American public culture demonstrates how the icon is a relational object—a conversation topic—around which publics gather, debate, and contest. However, the racial icon, while reflecting many of the features outlined in their work, has a different affective register pulled between the intertwined forces of denigration and veneration. Moreover, the racial icon addresses various constituents of the American public (and its many counterpublics) in drastically different ways, given the racial icon's tethering to historical and present racial inequalities.

Along the lines of Hariman and Lucaites, other theorists and cultural scholars have posed similar questions, asking why images matter, not only to the specific racial group represented, but within a national imaginary, or to paraphrase politicians, "where we are as a people." Others have argued that race is itself an iconic concept. W. J. T. Mitchell writes that "race is not merely a content to be mediated, an object to be

represented visually or verbally, or a thing to be depicted in a likeness or image, but that race is itself a medium and an iconic form—not simply something to be seen, but itself a framework for seeing through or (as Wittgenstein would put it) seeing *as*."[9] The racial icon then is doubly iconicized, given the conflictual relations embedded in the concept of race. Thus the racial icon—as object, photograph, or figure—acquires much of its significance from how race modifies and makes iconic, by default, images in public culture.

In focusing on black icons rendered through photographic media, I hope to demonstrate the specific features and realms of the black icon and black iconicity in American culture and the particular meaning attributed to black subjects *as* racial icons. One of the important distinctions is how the combined forces of veneration and denigration animate the black figure as racial icon. Unlike the Black Madonna of religious art, the contemporary black icon can never be completely purified and vaulted to a saintly status. The racial icon strives for that which is never quite reachable; thus it is, in other words, a chimera.

The racial icon is both an exceptional and a common figure. She or he is exceptional as a symbol of overcoming racial inequality and perceived inferiority; she or he is common, given the American public's familiarity and investment in exhausted notions of race, nation, and (under)achievement. Whether a self-conscious and deliberate construction or a product of circumstance, the racial icon—as image, political figure, celebrity, or sports hero—conveys the weight of history and the power of the present moment, in which her or his presence marks the historical moment. *To stand apart* and *to stand for* are the jobs of the racial icon.

Each chapter of this book presents a set of iconic images and a sector of American public life. Chapter 1 examines how racial iconicity emerges out of continued racial terror and violence by focusing on the making of Trayvon Martin

as a posthumous icon. The responses of many protestors to his murder and the viral "I am Trayvon Martin" campaigns that developed in response to his murder and the acquittal of his murderer, George Zimmerman, demonstrate the emotional power of the racial icon and how the iconic image gets deployed to garner public responses.

Chapter 2 centers on the significance of photographic representation of black leadership throughout modern social movements and civil rights struggles. Photographic genealogies of black political leadership represent self-conscious and highly orchestrated displays of race, nation, and family. These images come to serve important functions for various audiences, as seen in how cultural producers, designers, and consumers redeploy images of black political leaders to produce meaning of racial and national progress.

The iconic face of Diana Ross is the subject of chapter 3. By attending to Ross as a key celebrity icon of the civil rights and post–civil rights eras, the chapter argues that the racial icon is a tool of commerce, seduction, and fantasy identification. Motown, as a groundbreaking entertainment company founded by black entrepreneur and producer Berry Gordy, cultivated Ross as a mainstream pop icon. Ross then serves as a blueprint for many black entertainers and musicians who followed her.

Chapter 4 continues the exploration of the racial icon in popular entertainment sectors by focusing on the oft-celebrated, oft-condemned black athlete. The rarified position of the elite athlete is given considerable attention and value in American media and public culture. The professional athlete is akin to a national hero whose physical prowess and abilities are admired and praised by many. The black athlete has represented these attributes, as well as vexed notions of spectacle and threat, since the integration of professional sports. The chapter examines two contemporary black athletes, Serena Williams and LeBron James, who are precarious icons because of their uneasy relationship to

white American publics and their refusal to conform to certain expectations placed upon them in their respective sports.

The coda returns to the icon as the singular and the collective, the exceptional and the familiar. I consider the relationship between racial iconicity and racial vulnerability. This inquiry hinges on the polarity between the lauding of the racial icon and the dismissal and criminalization of black youth en masse.

The questions that animate and connect these chapters are: How does the racial icon serve as diagnostic and salve for the sickness that is the racial state? Moreover, how do the historical narratives and future trajectory of the nation hinge on the racial icon? How do history, photography, and embodiment work together to produce racial iconicity as well as obfuscate historical oversights and current dire conditions for black subjects and communities? How does the racial icon help produce a sense of national togetherness across disparate allegiances and modes of identification?

This book comes at a time when many antiracist activists and allies who seek a more just and equal nation have come to terms with the limitations of the racial icon as represented in the presidency of Barack Obama. For many, the Obama era has been a period that began with cautious hope during his first campaign, led to a growing optimism during the historic election, and then brought forth an unbelievable joy upon his first victory. This elation has been followed by a mounting frustration during his second term and impatience intermixed with disappointment, resignation, and dispassionate realism. Nonetheless, even in times of deep cynicism and resignation, the racial icon holds a hopeful promise. It is an assurance that *we* have achieved, or that we are on the road to achieving, that we are not slaves of history. It might also be a cry, especially in times of tragedy, that "we" will not let the mistakes of history prevent us from striving toward "a more perfect nation."

# *"I Am Trayvon Martin"*

## THE BOY WHO BECAME AN ICON

*ON RACIAL ICONS* took shape in the wake of the Trayvon Martin tragedy: his murder and the acquittal of his murderer, George Zimmerman. I was in the early stages of writing this book when Trayvon Martin was killed. Shortly after his death, public awareness of his murder spread internationally. I believe that it is important to preface this chapter with such a disclosure because my choice to include Martin touches on the stickier and more troubling aspects of racial iconicity: the interworkings of misfortune and opportunity, of terror and visibility, of injustice and hopefulness, of death and immortality.

In writing this chapter, I enact a mode of racial belonging and collective mourning that is conflicted in its use of substitution and that is cathartic in its attempt to make visible and to perform a long and continual process of grieving racial violence and morbidity. The significance of Trayvon Martin's killing to national and international publics reveals how certain deaths, especially racially motivated killings, acquire representation at specific historical periods. Moreover, through this tragedy and "our" coming together to protest and mourn Martin's killing, we might pause to consider the persistence of black vulnerability in the public sphere and how we sympathize with the suffering of some, and not of others.

On February 26, 2012, Trayvon Martin, a seventeen-year-old black American teenager, was killed while walking back to the home of his father's fiancée from a nearby convenience store in Sanford, Florida. George Zimmerman, a neighborhood watch guard, noticed Martin walking, followed him, confronted him, and ultimately shot and killed him. After noticing Martin from his vehicle, Zimmerman called the Sanford police and reported that Martin was acting suspiciously and that he looked "like he's up to no good" or "he's on drugs or something."[1] Zimmerman identified Martin's hoodie (a sweatshirt with a hood) as one of the features that marked Martin as suspicious. According to public records, the dispatcher told Zimmerman to remain in his vehicle and that an officer would be sent out to investigate. However, Zimmerman, as the saying goes (and as the history of American vigilantism and racism reveal), took the law into his own hands and pursued Martin nonetheless.

By the time the dispatched police car arrived, Martin was lying in a pool of his own blood, fatally wounded. It was not until the next day that Martin's father, Tracy, would learn of his son's fate. When the teenager was not home by the next morning, Tracy contacted the police to file a missing person report. Shortly thereafter, officers arrived at Tracy's home. They showed a photograph of a dead Trayvon Martin and asked if this was his missing son.

With little inquiry or investigation, the killing was quickly filed as self-defense by the Sanford Police Department under Florida's notorious justifiable use of force statute, most commonly known as the "stand your ground" law. Despite the fact that Sanford police questioned the credibility of Zimmerman's account of the events, Zimmerman was released under this law.[2] Even though the case was initially dismissed, these spare facts no one disputes: that Trayvon Martin was a black boy walking home, that Zimmerman deemed him suspicious, and that Zimmerman killed him.

Less clear, as cultural theorist Matthew Pratt Guterl points out, is the racialization of Zimmerman from the standpoint of familiar narratives of black/white racism in the United States. Zimmerman was assumed to be white when the news media first began reporting the case; yet as images of him began to circulate, they appeared to reveal an "ethnic identity" other than white. Later, some media outlets labeled him as "white Hispanic" and others continued to identify him as "white." Guterl explains: "This manifest racial ambiguity helped to complicate Zimmerman's motives, and to provide cover for those who wished to find a rational act. It was easy to think that some white trash fellow might have gotten a little crazy with a gun and shot some poor black child. It was harder to demonize a hard-working Latino, half Peruvian, or 'white Hispanic,' struggling to protect his precious property values."[3]

The story of that tragic winter's night in central Florida does not end there, although Martin's life did. While the local authorities readily dismissed the case, Martin's death reached international attention in large part due to the commitment of his parents, Sybrina Fulton and Tracy Martin, to seek justice for their son's murder. Their efforts were aided by the viral transmission of information through the Internet and the strategic use of Martin's image as part of their campaign for justice. In fact, many people learned about Martin's death through online petitions that were posted on Facebook and other social network sites demanding that Sanford's district attorney's office bring charges against Zimmerman. The outcry and protests of millions, including several high-profile celebrities and public figures, led to an inquiry by the Department of Justice and eventual charges against Zimmerman.

A prominent strategy to garner awareness of Trayvon Martin's death was the circulation of photographs of him as an "ordinary" teenager. I place "ordinary" in quotation marks because there is little doubt that a black teenage boy is never

seen as an "ordinary" American, let alone an "ordinary" child who deserves protection and guidance of adults and public authorities. Nonetheless, the photographs used in awareness campaigns by supporters of "Justice for Trayvon" are striking and compelling, given the context of his death and the state's efforts to absolve his murderer.

One photograph used in protests is a black-and-white self-portrait by Martin, known as a "selfie" in the social media landscape. The selfie is a form of representation that intimately projects how one wants to be perceived by an audience, especially among one's peers in the digital media realm. The selfie is a contemporary form of vernacular photography, the most widely practiced genre of photography since its inception. In its everydayness and the ease of access that consumers have to photographic software and technology in the contemporary era, the selfie makes self-portraiture a more common practice than in any other period in history. Although it often appears fleeting and can be erased in an instant by digital technology, the selfie is nonetheless part of the storied genre of portraiture. Like other portraits, the selfie is a deliberate representation of a public persona, a mode of self-conscious "sitting" in front of a photographic lens. Whether playful, sensuous, earnest, or aspirational, the selfie suggests a desire for recognition; it is a request for acknowledgment, an appeal to be a subject of value.

In this now famous self-portrait, Martin looks down into the lens with one shoulder raised as if he is leaning. He wears a hoodie. The lighting from above and the cap shaping his face create a halo effect. In the sheath provided by the hoodie, Martin's face appears to float. He hovers and levitates, as his eyes peer out from under his hood. The affect is that of a fore-shadowing, a speaking to audiences from the silence of death. Even as it feels as if it were a sort of premonition, Martin's selfie is also a performance of presence. He is, at that moment, alive, self-documenting and archiving his presence for meaning and

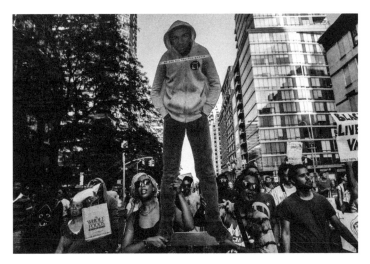

Figure 2. Trayvon Martin protest photograph of a life-size Martin cutout that incorporates Martin's self-portrait, New York City, 2013. Photo © Stephanie Keith Photography.

circulation. His downward tilted eyes avoid contact and yet they reveal an inquisitive gaze. This "ordinary" boy has captured an image of himself that, after his murder, circulates as a posthumous icon. The boy, who died in large part due to a "look" that rendered him suspect in public, becomes venerated through a self-image that captures that very look. With this singular photograph, we see how image and context work together to produce an icon.

As lethal and vile as racial intolerance and racial violence are, the forces of love, recognition, and the pursuit of justice are crucial to the emergence of Martin as an icon. We—as a public—know of Martin's harrowing fate because of the courage and dedication of his parents, who began an online campaign through a petition demanding the arrest of Zimmerman circulated on the website Change.org.

The parents' efforts led to other marches and protests. Through the embrace of Martin's photograph as part of the

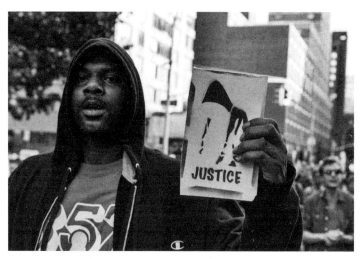

Figure 3. "Justice for Trayvon" protest. Photo © 2013, Tracy Collins, threeCee-Media.

"Justice for Trayvon" campaign, we witness the emergence of an iconic photograph, but we also isolate an iconic form—the hoodie—one that has resonated in public culture for years but that has become more complexly articulated in the wake of Martin's murder. The hoodie is an article of clothing identified with a generation of urban black young men and, for Zimmerman and many others, is a marker of black criminality. This article of clothing is steeped in the history of racialized style in the United States, in ways similar to the zoot suit of the 1940s. The zoot suit, too, was linked to racialized violence and the criminalization of black and Latino youth who wore the suit in defiance of wartime (white) patriotism.[4] Invoking the slang term *hood* (as in black and Latino poor and working-class neighborhoods) as well as the functionality of a hood attached to a sweatshirt or jacket, the hoodie acquired popularity through its association with hip-hop culture and urban black athletic wear starting in the late 1980s and 1990s. For example, on the promotional material for the 1992 "hood film" *Juice* directed by

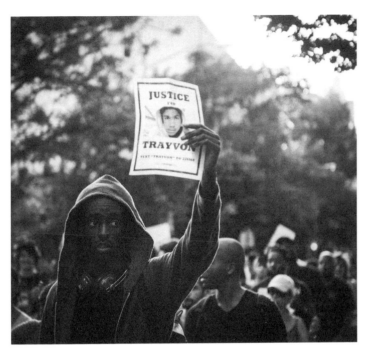

Figure 4. "Justice for Trayvon" protest. Photo © 2013, Tracy Collins, threeCeeMedia.

Ernest Dickerson, late rapper and actor Tupac Shakur poses in a dark hoodie with a look of foreboding in his sideway glance. While the hoodie registers urban, young, masculine, and black, increasingly it has become an article of fashion for non-urban, non-black, and non-youth groups. One of the most notable examples of its wearing is by Facebook cofounder Mark Zuckerberg, who chooses to wear his signature hoodie to corporate board meetings and in public appearances.[5]

The use of Martin's selfie in campaigns for justice led to a form of protest in which millions of people in countries around the world donned hoodies, posed before a camera, and proclaimed "I am Trayvon Martin." The protests took place on multiple platforms. At rallies small and large across the country, groups showed up in hoodies with signs declaring,

"I am Trayvon Martin" or "We are Trayvon Martin." Selfies were posted on personal pages of social media networks with members hooded, somber, and staring into the camera. Others used a black-and-white silhouetted graphic of a male profile in hoodie. The Miami Heat basketball team took a group photograph of the team hooded with heads bowed. Protestors who claimed "I am / We are Trayvon Martin" were politically, racially, ethnically, linguistically, and geographically diverse. They were representative of how complexly heterogeneous the twenty-first-century "American public" is. The protest portraits in this case expressed an infinite dynamism and multiple embodiment of racial iconic form, even in its tragic outcomes.[6]

The reaction of many to Martin's death registers subtle and enormous changes in the United States that can only be briefly sketched out here. It marks the profusion and rapid circulation of representation in the contemporary era. The number of photographs produced has mushroomed, largely because of the accessibility and relatively low cost of digital cameras embedded in portable consumer devices. The impact of digital photography continues to expand with the growth in photo-sharing sites.[7] In addition, the justice for Martin protests speak to the changing perception and reception of the icon and what it means to have "staying power" in a cultural climate where the consumption of images occurs more often involuntarily and with such rapidity and plenitude that it makes it challenging to hone in on a singular image. Furthermore, these photo-based protests signal generational and racial shifts among many black and non-black protestors. Masses of protestors imagine and (temporarily) identify with blackness in ways that are not through minstrelsy, slumming, or parody. Instead, one could argue that these images symbolically demonstrate an identification with racial isolation, profiling, and forms of abject suffering associated with certain groups of blacks and other vulnerable populations in this country and elsewhere.

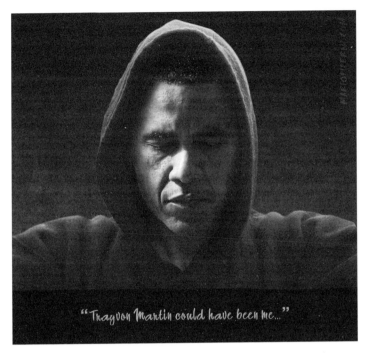

"Trayvon Martin could have been me..."

Figure 5. "Trayvon Martin Could Have Been Me," Obama in hoodie, July 2013. Illustration by Mario Piperni—mariopiperni.com.

In this light, many non-blacks are able to recognize a young black male as a sympathetic character—as one with whom they form a deeply emotional and performative attachment, a type of claiming—and to see the machinations of structural and quotidian racism to portray him as other.

The emotional waves of identifying with Martin reached the White House. Whether rooted in perceived or actual public pressure or a personal sense of the shared experience of racial profiling, President Barack Obama felt compelled to link his life outcomes to those of Trayvon Martin. A month after Martin's murder, the president spoke publicly about the killing. Many have argued that, as president, Obama has been cautious in speaking about race because of the expectations

of many that he should address the significance of race in the
nation's past and present. After growing tensions about Mar-
tin's murder and pressure from the public to see justice in Flor-
ida, Obama went on record stating, "You know, if I had a son,
he'd look like Trayvon."[8] The president's words affirmed what
many sympathetic to Martin's parents felt. For some on the
front line of protesting, there was cautious hope that Obama
would be more vocal and active in his stance against racism.
Contrarily, he was widely criticized by politically conserva-
tive commentators and constituents and was accused of race-
baiting. Yet even still, after the acquittal of George Zimmer-
man, Obama seemed to identify even more closely with Mar-
tin. He spoke of his own experiences of being racially profiled
and then stepped into the dead boy's shoes by claiming, "Tray-
von Martin could have been me."[9] His statement both led some
to question what connects Obama to a seventeen-year-old boy
who died so violently, so painfully, outside a gated commu-
nity in Florida and helped to ensure that boy's iconic status.
Obama's assertion seems even more intentionally jarring given
how very different the backgrounds and outcomes of their lives
are. What Obama was signaling was an affective kinship that
linked him to Martin in a racial fraternity of being marked as
public threats and being subject to extreme forms of violence
because of that marking.

As much as the "I am Trayvon" campaign and the iden-
tification with Martin among broad sectors of Americans,
international protestors, and the president of the United States
signal important shifts in American public culture, they also
raise troubling questions. Digital media make it easy to sub-
stitute and circulate oneself in place of the subject of racial
violence, and the hooded selfie became a popular way to claim
progressive politics with minimal efforts. The millions of por-
trait protests and statements taking on Martin's identity are
discomforting in this form of substitution. Simply put, none of

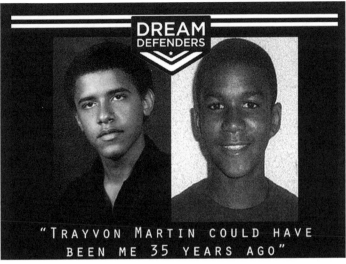

Figure 6. Dream Defender poster of a young Barack Obama and Trayvon Martin.

the hooded protestors is Trayvon Martin. *They are not the dead son of Sybrina Fulton and Tracy Martin.* They are alive and their future outcomes are yet to be determined. As troubling as I find this campaign, I do take heart in this affective movement of a large number of American and international publics in the face of Martin's murder, and here the word *public* seems to be rightly used as it is defined—an imagined group who will never in fact meet each other.

### THE ICON AND HISTORICAL RECURRENCE

In addition to such highly personalized identification with Martin, another significant way that many made sense of Martin's murder was through the framework of historic recurrence. Comparisons have been made between Trayvon Martin's murder and image and that of Emmett Till, whose battered body was captured in a photograph that also gained enormous public attention. In 1955, Till, a fourteen-year-old black boy who

lived in Chicago, was brutally murdered by a group of white men while he was visiting his relatives in Mississippi. Till's murderers, Roy Bryant and J. W. Milam, were acquitted, but they later confessed in *Look* magazine.[10] Till's torturous killing was crucial in galvanizing support for black civil rights and freedom struggles across a broad sector of national and international publics in the mid-twentieth century.

Till's murder built awareness in large part due to his mother's refusal to let the injustice of her son's killing be rendered invisible. Mamie Till held an open-casket funeral for Emmett so that all could see how her son had been brutalized. "Some 50,000 people streamed in to view Emmett's corpse in Chicago, with many people leaving in tears or fainting at the sight and smell of the body."[11] Because Mamie Till allowed photographs of Emmett's funeral, including a close-up of his brutalized face to be published in *Jet* magazine, his murder garnered even greater outrage. Millions were moved to action or at least to greater support for civil rights after viewing the images of his dead body and disfigured face that circulated internationally through print media. Considering the impact of Emmett Till's murder for black Americans and the growth of the civil rights movement, historian Robin D. G. Kelley asserts: "The Emmett Till case was a spark for a new generation to commit their lives to social change, you know. They said, 'We're not gonna die like this. Instead we're gonna live and transform the South, so people won't have to die like this. And if anything, if any event of the 1950s inspired young people to be committed to that kind of change, it was the lynching of Emmett Till."[12]

In examining the legacy of Till's lynching and the iconic photograph of his postmortem face, scholar Myisha Priest queries: "If we follow Mamie Till's insistence that justice begins at the moment we look at the body of Emmett Till and hold at once the vision of his humanity and what was done to him—a complicated and shifting model of resistance that motivated

political action and political change throughout the civil rights movement—then we return to the idea that there is an avenue to justice to be found in his flesh. If so, what kind of justice might that be? Can there be a revelation of the flesh that does not further violate the body?"[13] Taking up Priest's provocation, what significance does photography play in this process of envisioning Till's humanity and journeying toward justice through his brutalized flesh? Even more, how have specific images served as vessels for various publics in different historical periods to *feel* black flesh and racialized suffering?

In both the cases of Till and Martin, the raw facts are that two black boys were killed through acts of racial policing and terror and that their murderers were not convicted. There are also important distinctions between these cases and the time periods when they occurred, as well as key differences between the iconic photographs, in their reception and circulation. While the photograph of Martin lends itself to mimetic reproduction ("I am Trayvon Martin"), the photograph of Emmett Till does not. Martin's photograph projects a type of vitality and wellness in its "typicality" as self-portraiture and "innocence" as the self-exploration of a teenager. In contrast, the brutalized and distorted features of Till's face are the subject of memorializing, not mimesis. His posthumous face serves as transparent and horrifying visual evidence of racial violence targeted at black boys and men.[14] Thus we cling to Martin's iconic image and identify with him, and we hold Till's iconic image at a distance, feeling the weight of its gravity and hoping to avoid its outcomes.

### The Dead Icon on Trial; or, The Prosecution of Martin's Image

It is not an exaggeration to write that in the weeks and months after Martin's killing, millions of people clung to the selfie of Martin in his hoodie. The attachment to Martin's

image and its significance to how various constituents of the American populace understand racialized embodiment, racial violence, and (lack of) access to the public sphere grew more palpable during the struggle to have Zimmerman prosecuted for Martin's death. In the days and weeks after Martin was killed and without any public prosecutorial action, protests and identification with his image grew more urgent and virulent. Six weeks passed from Martin's death on February 26, 2012, until special prosecutors announced charges of second-degree murder against Zimmerman on April 11. The shift from the Sanford Police Department's initial response to the killing to Zimmerman's indictment was solely a result of the widespread public pressure from local, regional, national, and international realms to see Zimmerman prosecuted. It is not an overstatement that protests and public opinion in support of "Justice for Trayvon" led to charges against Zimmerman.

After Zimmerman was charged, the route to "Justice for Trayvon" lay in the hands of a trial by jury (in this case, composed of one Latina and five white women). While his role as Martin's killer was clear, the question remained whether Zimmerman would be held accountable by jury. Even more of a concern was whether the jury would hold the same biases that Zimmerman held about the murdered boy because of Martin's race, youth, and fashion. During the trial, in the blogosphere and other media outlets, much was made of the testimony and treatment of Rachel Jeantel, the teenage friend of Martin who was speaking to him by cell phone when Zimmerman approached. Jeantel was widely dismissed and disparaged because of her use of urban vernacular speech while on the stand and what was perceived as her racially inflected style and a punitive, pathologizing, reading of her body. Also apparent was the lack of preparation of the prosecutors and their assumption that Zimmerman's conviction in the court of public opinion would translate to his being found guilty by a jury.

At the same time that the prosecution stumbled, the defense borrowed the strategy of "Justice for Trayvon" protestors by using images of Martin to build their case of *why* Zimmerman would have feared for his life when confronting Martin. Their argument was that Martin's photographic record—especially through social media—evidenced why Zimmerman would have seen Martin as suspicious and therefore why Zimmerman would have taken such extreme actions to protect himself and his community, as a "stand your ground" defense.

On July 13, 2013, after sixteen and a half hours of deliberating, the jury acquitted George Zimmerman of second-degree murder and manslaughter charges.[15] Even with the media pundits questioning the prosecution's strategy during the trial, the ruling came as a shock to national and international audiences. No one, including the defense, had doubted that Zimmerman had profiled, followed, and killed Martin. For some who had followed the televised trial closely, the verdict was not so much a surprise but another terribly painful wound, evidence yet again of the continued and flagrant disregard for black life. Given systemic racism and injustice in the United States, some scholars and critics, in fact, argued that Zimmerman's acquittal was not an anomaly, but was an example of the workings of the U.S. nation as a racist state. Robin D. G. Kelley, writes: "The point is that justice was always going to elude Trayvon Martin, not because the system *failed*, but because it worked. Martin died and Zimmerman walked because our entire political and legal foundations were built on an ideology of settler colonialism—an ideology in which the protection of white property rights was always sacrosanct; predators and threats to those privileges were almost always black, brown, and red; and where the very purpose of police power was to discipline, monitor, and contain populations rendered a threat to white property and privilege."[16]

Figure 7. "Justice for Trayvon" protest. Photo © 2013, Tracy Collins, threeCeeMedia.

Immediately following Zimmerman's acquittal, there was nonstop coverage and protests against the verdict. I, like many (especially black mothers), felt and still feel heartbroken, demoralized, shocked, and enraged. For so many of *us*, the series of events around Martin's murder and Zimmerman's release—with the image of Martin at the center of the protests and the trial—is the reopening of a deeply painful wound. Since his death, photographs of Martin circulate as palliation and wound. In some pictures, Martin smiles; here he floats about on paper and electronically as a thoughtful and loving child and friend. We—the sympathizers and the silent majority—are encouraged to see him as earnest, curious, sweet, and *innocent*: an impossible stance for a black boy in a racial state where blackness is by default suspicious. In a notable photograph used by protestors to untangle the visual and symbolic codes that align blackness with deadly threat, Martin poses with his father, who hugs and kisses his son. Here a child receives recognition, protection, and guidance; this is a child who is deeply loved and cared for.

Figure 8. Trayvon with his father, Tracy Martin. Photo released to public by family of Trayvon Martin.

Yes, a boy was murdered. We love him in all his photographic beauty posthumously as another victim of racial violence. This boy, Trayvon Benjamin Martin, was the son of Sybrina Fulton and Tracy Martin. He was the brother of Jahvaris Fulton and a cousin and friend to many. He was born on February 5, 1995, and died one terrifying evening, shortly after his seventeenth birthday, as he walked from a convenience store. There is no longer a living Trayvon Martin to flesh out what a photograph cannot contain: his corporeal presence, an experimentation with life's possibilities, a future based in childhood dreams, an offspring. There will never be another indexical photograph of an embodied and maturing Trayvon Martin to complicate the widely circulating images of him, especially the photograph of a dead black boy that circulates in his postmortem state.

Trayvon Martin is a historical figure. He is a dead black boy. He is an index. He is a specific case. He is a symbol,

an icon. He is all of this, and more. Martin's image has been reproduced many millions of times since he died on the sidewalk outside a gated community where he was visiting. He is a goofy boy with a young female confidant, Rachel Jeantel. He is an aspiring pilot. He enjoys watching the National Basketball Association. He poses with "grills" (removable, adorned, frontal dental pieces made of gold, platinum, or diamonds). There he is posterized, as a Facebook profile picture, as a flyer passed around to announce a demonstration, as a billboard. On T-shirts and hoodies, Martin is silhouetted. He is our baby boy whom we want to hug; he's our warning sign of what happens to black boys. He is a threat in the minds of racist paranoia. Martin's image moves through various locations and media platforms. Martin circulates as material object, viral transmission, traumatic wound, and historical fact. Martin lives through his image, because of our attachment to it, our attachment to the historical legacy of blacks, to black masculinity, and to the historical present of racial subjugation.

I have never worn a hoodie in honor of Martin. At the same time, I am part of the "we"-making machine, but I need to imagine that there are others, many others, who share with me the abiding wish that Sybrina and Tracy have their son, alive, and in their arms. We intimately enfold the image of Martin, smiling from under his hoodie, into our narratives of family, belonging, and love. We publicly memorialize Martin's photograph and murder as part of the long, painful, and unfolding narratives of race, violence and the American public sphere. *We* are not Trayvon Martin. We are alive. Like him, though, those of us who are vulnerable to the terror and violence of racial hatred, we hold his photograph even more tenderly.

Why are we not all Marissa Alexander, a young black woman arrested when she claimed "stand your ground" for protecting herself from her abusive husband in Florida?

Alexander's case has been the subject of media coverage in the wake of Martin's death and Zimmerman's acquittal. In social justice circles, her case has come to represent the disparities between convictions and sentencing of blacks and whites and also the structural and legal barriers against women who defend themselves against their abusers. While many sympathize with Alexander, the public impulse has not been to claim identification with this young woman—currently alive—who has suffered from multiple forms of intimate and state violence. Why are we not marching as the millions of others who are terrorized, imprisoned, and killed by the structures of racial violence that devalue black life, such as the many young blacks who have died at the hands of other young blacks in Chicago? The indexes of those impacted are so numerous and so quotidian that we gravitate even more strongly to the singularity of the icon—the beautiful face of a black teenage boy peering out from under his hoodie, seeking recognition. When we can isolate the image and hone in on a specific instantiation, then the emotional floodgates and the historical baggage pour out with all its weight onto that one boy.

# *Democracy's Promise*

## THE BLACK POLITICAL
## LEADER AS ICON

IN RESTAURANTS, ON BUILDINGS, in homes, and in public sites across the country and around the globe, images of President Barack Obama as the manifestation of a long line of "great black leaders" proliferate. On a food cart in Harlem, Obama's smiling face spans the border alongside the more austere portraits of Frederick Douglass and Martin Luther King Jr. On a gallery wall in Boston, a photorealistic painting by Ron English blends Obama's face with a well-known stately portrait of Abraham Lincoln. The painting of Lincoln, the "great slave liberator," and Obama, the son of a white American woman and a black Kenyan man—not a descendant of American slavery—is aptly titled *Abraham Obama*.[1] The image has been reproduced and posterized on street poles, sidewalks, and bus stops. Obama's image is one that so many from different races, nations, generations, languages, and politics have taken pride in at some point in his political and media ascendancy.

President Obama is a heroic figure obsessively represented by many who deliberately work to visualize his iconic status. The term *icon* works on multiple levels in the case of Obama. He is an embodied subject: a racialized man sometimes referred to as biracial or mixed-race, but routinely touted as the pinnacle

of black leadership. In this way, he is also a historic figure who stands in for democratic progress and racial equity. He is also represented as a deity, a messianic figure delivered to earth to undo racial injustice. In all of these examples, he is a visual sign: both singular and multitudinous as representation.

In posters and photo-collages, Obama marks the end in the long struggle for black political representation and value; and he is the beginning, for many, of a new era of possibility for individuals, racial groups, and the nation at large. He is the American icon—the fullest possibility of the nation. In image after image, he is surrounded by symbols of the nation, including passages from the Constitution and other political documents and speeches. He is also figured as an international icon, the recipient of the Nobel Peace Prize. In this iconic landscape, Obama stands with a succession of national and international freedom fighters, including Gandhi, Malcolm X, and Nelson Mandela. Obama, the first black president of the United States and the triumphant exemplar of American democratic and racial iconicity, circulates in American and global public cultures in ways more diffuse, contradictory, and abundant than presidents and black leaders before him. Before the digital shift, the public's exposure and engagement with racial iconicity took place via traditional mass media and print culture (books, magazines, leaflets, television). In the twenty-first century, however, access is multivalent, and images circulate in more expansive and quotidian ways. One example is the common usage of photographs of iconic figures as social media profile pictures, such as Malcolm X on his birthday. Thus we can largely understand the wide distribution of Obama's image as emblematic of our technological times. At the same time, it is important to consider how the convergence of racial politics, political leadership, celebrity culture, and media industries produced Obama's iconicity as the exemplar and fruition of U.S. democracy's promise.

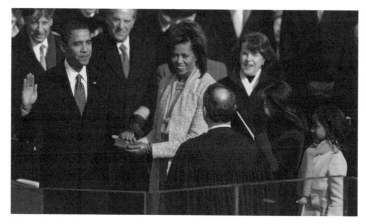

Figure 9. The inauguration of President Barack Obama, January 2009. Photo Matthew Cavanaugh / EPA.

Obama's rise and the power of his image evidence the role of the visual in anticipating political change and in making racial justice iconic through the representational politics of black leadership. Of particular note is the redeployment of familiar archival photographs of civil rights struggles and black political leadership as masses imagine the trajectory of President Obama as the penultimate achievement of racial uplift for black and non-black Americans, and moreover a global audience. Considering more broadly the iconic trope of a black president (even prior to its actualization), literary and cultural theorist Erica R. Edwards writes, "the black president, as a cultural icon of black middle-class success after civil rights, is a referent for public black anxieties triggered by the shift in public black political culture from social protest to electoral politics after 1968."[2] Edwards's analysis speaks to the particular investment of many black Americans in having a black man as president of the United States, as marker of a linear movement from racial struggle to racial achievement. Black and non-black consumers and cultural producers have worked, visually and otherwise, to map Obama's trajectory as predestined by

linking him to a genealogy of black male leaders. President Obama is cropped, edited, digitized, manipulated, and recirculated as the highly anticipated culmination of a long line of black male leadership and achievement.

These virtual and visual redeployments of racial iconicity by various constituents—social media producers, artists, journalists, critics, consumers—offer insight into how a broad spectrum of people nationally and globally code the history of the United States as a positivist narrative of racial struggle toward individuated achievement. These visual projects rehistoricize race and nation by positing the political rise of a black male leader as the high mark of a democratic and free nation. Within these politico-scapes, there is a claim to the furthest reaches of normative and hegemonic power, even as the trajectory meanders through motley genealogies of political evolution. The convergence of the black political leader as community activist with his position as leader of "the free world" deserves special attention, given the importance of the first to black freedom struggles and the second to mainstream reformist politics. The ambiguous link between the two fuels continued debate across racial and political spectrums about whether Obama is a president for all Americans.

The "promise of American democracy" is meant to capture the continued striving of oppressed populations, here blacks, to force the nation to live up to its ideals. However, this striving leads to perpetual disappointment, because the nation through its very constitution is a hierarchical, racialized state, even as it claims to promote "Life, Liberty, and the pursuit of Happiness" for all. More precisely, American democracy's promise is a means of narrating, and at times normalizing, the routinized practices of violence that have been essential to the operation of commerce, industry, and capital in the United States. In this respect, the black political leader as racial icon mirrors the tensions and contradictions

between the rhetoric of democracy's promise and the violence of our racial state.

As a reflection of the U.S. civil rights movement, Obama's presidency symbolizes a restoration of the racial past and present. His political achievement is an ideal bookend for a sector of the civil rights movement primarily concerned with electoral politics, as Edwards's quote elucidates. From this vantage point, Obama both represents and embodies democracy's promise. The promise is that the United States will inevitably experience a form of redemption for its genocidal and exploitative origins and fulfill its hubristic destiny as the greatest democratic nation in history. Obama often rhetorically gestures toward this imagined racial and political landscape in his recurring invocation of the preamble to the U.S. Constitution: "to form a more perfect union." He thereby harkens back to the rhetoric and visual symbols wielded by previous generations of black leaders, from black abolitionists to civil rights leaders who demanded that the nation live up to its principles and ideals. The former slave and well-known black abolitionist Frederick Douglass mastered "use of the iconography of the founding fathers and the Declaration of Independence in his call for liberty, and there is no better example of his manipulation of that iconography than his 'What to the Slave Is the Fourth of July?'" As literary historian Ivy Wilson notes, "His popular oration dramatizes his views on how slavery reduced democracy to a mere specter of itself."[3] Wilson also emphasizes Douglass's attention to the power of visual media in his advocacy of freedom and humanity for blacks in the antebellum era. In his writings on these issues, Douglass prefigures the complex interrelation of progress, nation, photographic media, and blackness.

### VISUALIZING BLACK FREEDOM
### STRUGGLES AND LEADERSHIP

Frederick Douglass's life overlaps with the creation and growth of still photography. Early on, Douglass claimed that photography had the potential of humanizing slaves in the eyes of the white American public and "for remaking the American imagination."[4] Since photography's inception in the nineteenth century, it has served as an important medium for documenting progress for black Americans and the concerted efforts to be recognized as full-fledged U.S. citizens.[5] It has also served as a brutal tool to surveil, criminalize, and devalue blacks. Like Douglass, many black Americans in the antebellum era saw promise in photography to produce a visual record of humanity that had been denied them in most spheres of American life. The medium also served as an important counterpoint for the dehumanizing imagery of slaves and black citizens that had been used to reinforce the racial state. Condemning the gross depictions of "Negroes" in nineteenth-century American culture, such as the caricatured images in *Harper's Weekly* and other popular print media, Douglass saw in photography the means for black self-representation and self-determination.[6] In his speech "Pictures and Progress," he celebrated the possibilities offered by the new technology, stating that "for nothing is this age more remarkable, than for the multitude, variety, perfection, and cheapness of its pictures" and "the humblest servant girl may now possess a picture of herself such as the wealth of kings could not purchase fifty years ago."[7] Thus, for Douglass, photography held the possibility for blacks to claim the promise of American democracy.

The research and writing of Deborah Willis, Shawn Michelle Smith, Jasmine Nichole Cobb, and other scholars have exposed a rich archive of images that Douglass's writings presaged. These nineteenth-century and early twentieth-century

photographs make visible to historical and contemporary viewers the aspirations and struggles of black Americans from the end of slavery onward. As Maurice O. Wallace and Shawn Michelle Smith write, "Evolving contemporaneously with this near-seismic shift in the demography and meaning of free persons, photography helped to adjudicate the meaning of freedom, picturing its African American subjects from the day of the daguerreotype to that of the silver print."[8] Throughout the late nineteenth century and into the twentieth century, the use of photography as a mode of self-determination for blacks—individually and collectively—grew. Employing photography to visualize black people's aspirations became more widespread with the growth of black studio and portrait photographers in black communities during the early twentieth century.

Producing images of black leaders and leadership has been a central fixation of those who strategically use photography for racial uplift. The strategy can be traced back to Douglass, who not only theorized about photography's potential for black self-determination but also put his theory into practice by sitting for a series of portraits over several decades. Douglass, in the convention of nineteenth-century photographic portraiture—"the three-quarter bust, the oblique angle, the gaze directed toward the right as the viewer sees it"—sits for the camera in formal attire with an austere gaze of self-possession.[9] Ginger Hill writes: "Douglass's own constant sittings for portrait photographs suggest a strict concern with visual form. His precise public image conforms to monotonous, middle-class standards of legible self-possession and proper—which is to say, propertied—public standing."[10] While Hill explicates how Douglass conforms to the conventions of the genre and era, it is also important to note how he used photography in an important and calculated claim for respectability, a central demand among blacks struggling for rights, recognition, and dignity over many generations. In his

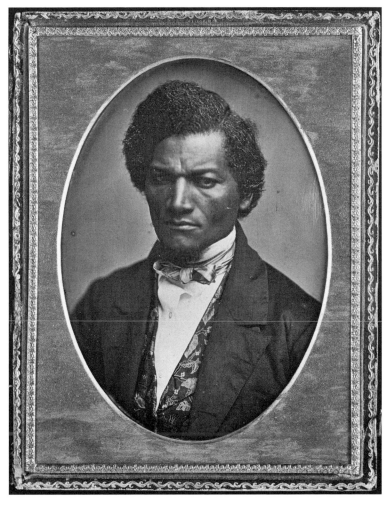

Figure 10. *Frederick Douglass*, 1847–1852, by Samuel J. Miller, American, 1822–1888. Daguerreotype, 14 × 10.6 cm (5 ½ × 4 ⅛ in., plate). Major Acquisitions Centennial Endowment. Courtesy of the Art Institute of Chicago.

portrait series, Laura Wexler points out, Douglass strategically visualizes his journey from slave to orator, writer, and abolitionist. Moreover, the repetition in form and composition of his photographic portraits, along with his own writings about image and photography, demonstrate his belief that "self is determined by the right to self-possess and possess rights."[11]

In each of his portraits, Douglass offers a singular, exceptional vision: a black man who emerges through a brutal racial state to become a leader of his people. At the same time, these portraits are representative of the potential of the race as a whole. Certain visual tropes established and rehearsed in the portraits of Douglass, and later Booker T. Washington, W. E. B. DuBois, and other civil rights icons, are typical of studio portraiture of great men. Yet there is a level of self-conscious restraint, discipline, and sobriety that is crucial to representations of black male political leaders that move beyond genre practices. These self-conscious performances and visual productions are rehearsed throughout the modern photographic era, even as they are also challenged by images of racist violence and caricatures of black excess and incivility.

In addition to documenting black political leadership, photography became an important strategic tool for civil rights activists in the mid-twentieth century, not only to capture black hopes and aspirations for freedom and equality, but also to publicize the widespread brutality of the racial state against black freedom fighters.[12] Edwards writes, "The intergenerational relationships and social networks forged in local organizing efforts during the decades before and after World War II made the movement more complex, more diverse, and more ordinary than the spectacular accounts of race men making speeches on the evening news were willing to allow."[13] Her study turns our attention to counter-histories and alternate narratives that bring to center stage the many millions involved in the struggle for freedom and equality for black Americans.

Photographs such as the 1967 Pulitzer Prize–winning image of James Meredith (the first black student to integrate the University of Mississippi) gunned down by a racist sniper during a civil rights demonstration are foundational to how we understand the movement and what racial struggle entails.

Memorializing the civil rights movement is a photographic project that involves the continual circulation of familiar images. Scholar Leigh Raiford writes, "Because these images are seared as they are in national and racial imaginaries, revisited and repeatedly invoked well beyond their moments of origin, the photographs compel an examination of ongoing processes of iconization, to ask how history crystallizes and meaning accumulates."[14] As Raiford's statement suggests, racial iconicity is essential to how we grapple with the complexities of race, nation, and the promise of American democracy. The visual legacies of black freedom and civil rights struggles provide crucial context for the popularity and circulation of Obama's representation in the contemporary era. These legacies and their photographic archives do not simply provide context for Obama's presidency, but they often get incorporated into visual images—such as posters and collages—that mark Obama as part of a genealogy of black male leadership.

### From the Mountaintop to Capitol Hill: Visual Genealogies of Black Male Leaders

The poster series "Thinker" mirrors how historical icons are incorporated into visual depictions of Obama's rise through a masculine trajectory of racial achievement. There are multiple versions of the posters that appear to be designed by different people and that are sold by various poster and online art sites. In one version of "Thinker," Obama appears in contemplation with hand to face, alongside portraits of similarly

posed black figures from earlier eras: Martin Luther King Jr., Malcolm X, Nelson Mandela, and Bob Marley. Under each iconic figure is a key word: *peace* for King, *power* for Obama, *respect* for Malcolm X, *dignity* for Mandela, and *love* for Marley. Besides the assumed commonality of their black maleness, what brings these five figures—one Jamaican, one South African, and three American—together in this visual narrative? The poster designer imagines a legacy that interweaves a cultural trailblazer whose music has become a global anthem for freedom, a political revolutionary turned president who spent twenty-seven years in prison because of his opposition to apartheid in South Africa, two men who used different strategies to fight for black American civil rights in the mid-twentieth century, and one Ivy League–trained law professor who went from community organizer to president of the United States. The designer invokes notions of black diasporic kinship in linking the Jamaican, South African, and black American icons with the ambitions, hopes, and dreams of the poster's audience. It thus brings together a collective diasporic imagining and an individual vision of leadership.

In another version of the "Thinker" series, Obama, Malcolm X, and King reside as the trinity of modern black American leadership. While the poster uses some of the same images and key words of the previously discussed one, the message here is quite different with its sole focus on three black American political leaders from the modern era. In this political trinity, Obama is not at one end of the poster (which compositionally would suggest a historical linear trajectory). Instead, he is positioned between King and Malcolm X in a strategic manner that allows for multiple meanings. Positioned between the two most well-known black American political activists of the twentieth century whose ideologies often have been framed in opposition to each other, Obama mediates between the popular understandings of King and Malcolm X, between

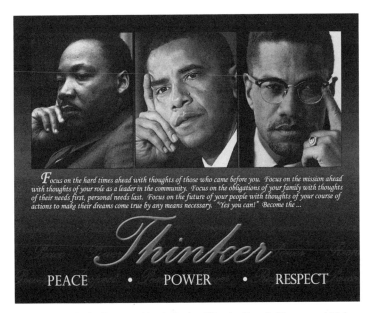

Figure 11. "Thinker" poster: Martin Luther King Jr., Barack Obama, and Malcolm X. Courtesy of Michael W. Eaton.

reform and radicalism. Alternately, Obama can be read as an offspring of this dual male lineage.

Each photograph on all versions of the "Thinker" series is a familiar image. The design plays on the ease with which these iconic men are recognized for their accomplishments and legacy within black political and cultural histories. In terms of historic progression, all of the figures, except for Obama, have died, although the affective power of each image is quite alive. On both versions of the poster described here, a caption in italics reads:

*Focus on the hard times ahead with thoughts of those who came before you. Focus on the mission ahead with thoughts of your role as a leader in the community. Focus on the obligations of your family with thoughts of their needs first, personal needs last. Focus on the future of your people with thoughts of your course of actions*

*to make their dreams come true by any means necessary. "Yes you can!" Become the . . . Thinker!*

The message seems geared toward aspiring black male leaders and activists. Family, community, race, and nation are enfolded as the responsibility of benevolent black male patriarchs. The "Thinker" series thus attempts both to map a genealogy of iconic black male leaders and to provide a blueprint for aspiring leaders.

In several visual imaginings of black political leadership, Obama's presidency stands as the manifestation of Martin Luther King's "I Have a Dream" speech. In the photo-collage titled *MLK Meets President Obama 2013*, half of the image consists of a cropped black-and-white photograph of King during his 1963 March on Washington speech. King stands at an angle, slightly smiling as he salutes the crowd with raised arm and hand. In the background, masses of marchers congregate to hear his address. The Lincoln Memorial is visible in the distant horizon. The right side of the photo-collage consists of a partial photographic image of Obama's second inauguration in January 2013, almost fifty years after the historic civil rights march. The cropped photograph of Obama is characterized by a distinctly twenty-first-century aesthetic: a digital color scheme that emphasizes the blues and reds of the image. Obama's hand, similar to King's, is outstretched as he addresses the celebratory crowd. Fifty years apart, Obama's and King's fingertips touch in this historic arc of black American political achievement.

In this majestic space above their followers, there is silence. They are of the people—that is, representative—and beyond the people—that is, transcendent. This meaning is made visually evident by how each charismatic leader foregrounds his many followers, angled behind him and serving as the backdrop to black political greatness. Yet we can point to some important distinctions between these two crowds of enthusiastic listeners.

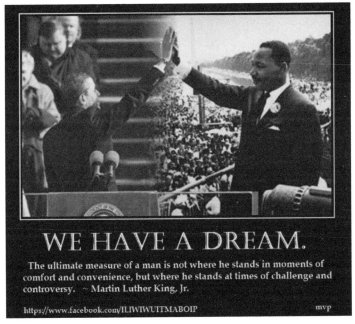

WE HAVE A DREAM.

The ultimate measure of a man is not where he stands in moments of comfort and convenience, but where he stands at times of challenge and controversy. ~ Martin Luther King, Jr.

https://www.facebook.com/ILIWIWUITMABOIP                         mvp

Figure 12. *MLK Meets President Obama 2013.* Courtesy of "I love it when I wake up in the morning and Barack Obama is President" Facebook Community administrator and the Progressive American online community.

In the case of King, the crowds were beleaguered, many protesters having suffered through the forces of brutality in the battle for equality. King's speech can be seen as an attempt to inspire freedom fighters, whose bodies were literally on the line in protesting racial injustice and state terror. In some respect, the followers of Obama are self-congratulatory; they have accomplished a major historical feat twice: the election and reelection of the first black president of the United States. In regard to Obama's audience, many see themselves at the end of a triumphal narrative, rather than, as in 1963, at the beginning of an uncertain and dangerous journey.

King's oft-quoted "I Have a Dream" speech has been redeployed and interpreted as foreshadowing the conditions that

produced Barack Obama. More aptly, Obama's rise is seen as the fruition of King's dream. Some interpret this connection as racial achievement: the ascendancy of a black man to the highest office in the land. For others, it marks the end of race as a category of significance: a deflection of race as reflective of a postracial state in which representational politics are no longer central. Commenting on the euphoria and the religious overtones of various American publics in building an alignment between Obama and King, cultural theorist Hortense Spillers writes, "A sense of the historical . . . renders Obama's election a teleological event, or, more precisely, an event that is apparently charged with a radiance so brilliant that it is spoken of variously as the fulfillment of King's dream, as the completion of the civil rights agenda, or, in theological terms, it rehearses the Good News story of suffering in the case of a people blessed at last by an irremediable beneficence."[15]

President Obama has been self-conscious in linking his political rise to King's legacy and to a religious destiny of the nation. For example, King greatly influenced Obama's rhetorical style and speech delivery. In particular, Obama echoes King in pointing to the notion of American democracy as visible on the horizon and the nation as possessing the potential for greatness if only its citizens can truly overcome its historical and present "sins" of racial and class inequalities. Yet there are some significant distinctions that challenge the ease with which Obama is linked to King's legacy. Obama borrows the rhetoric of a mythologized predestined nation, but he makes only vague references to what ails the nation, notably racial and class oppression. The president, in his concerted effort to "encourage Americans across every possible group line to recognize one another as being part of a single community of Americans based on our shared membership in the civic nation," connects democracy's promise to a claim of a mythologized future without an adequate address to systemic inequalities of the past and present.[16]

King's "Dream" speech was a critique of state policies and practices that kept (and continue to keep) millions in poverty and despair. First performed at the 1963 march, which took place on the one hundredth anniversary of the Emancipation Proclamation, King stated: "In a sense we've come to our nation's capital to cash a check. When the architects of our Republic wrote the magnificent words of the Constitution and the Declaration of Independence, they were signing a promissory note to which every American was to fall heir. This note was a promise that all men—yes, black men as well as white men—would be guaranteed the unalienable rights of life, liberty, and the pursuit of happiness. It is obvious today that America has defaulted on this promissory note insofar as her citizens of color are concerned."[17]

While Obama borrows the rhetorical flourish and expansive language of King, the historical narrative of equality and opportunity that he crafts is drastically different. In a much-cited speech on economic mobility given in his second term, President Obama asserts: "Now, the premise that we're all created equal is the opening line in the American story. And while we don't promise equal outcomes, we have strived to deliver equal opportunity—the idea that success doesn't depend on being born into wealth or privilege, it depends on effort and merit. And with every chapter we've added to that story, we've worked hard to put those words into practice."[18] These two quotes reveal the ideological gap and the fundamental contradictions that exist in the production of a history of black iconic leadership. In essence, Obama deploys a radical legacy and a highly affective rhetorical style to solidify meritocratic notions of American exceptionalism and superiority. The trajectory that he lays out in such speeches can only exist by not fully coming to terms with the extent to which race has shaped wealth and life outcomes in myriad ways. From the logic of Obama's speech, economic equality is necessary as an example

of the nation's greatness, not as a critique of its fundamental and deep-rooted inequalities. Such messages from Obama (as the embodiment of black political aspirations) secure the legitimacy of America's democratic promise by limiting attention to the nation's fundamental flaws.

Given the differences in historical eras and political positions of King and Obama, it is not surprising that iconic photographs of the two leaders have also been used to condemn the president's policies. In these visual counter-narratives, Obama represents a disappointment, or even a disgrace, of King's dream and those who marched for racial justice. Such are the underpinnings of the photo-collage and Internet meme *I Have a Dream. I Have a Drone.* The viral poster uses dark humor and text to express the malaise that many progressives and dreamers have felt in the Obama presidential era. After the initial elation of his election, it became apparent to many who wished otherwise that Obama would not take on the role of civil rights activist and that he would uphold some of his predecessor's policies. Among the more controversial policies that George W. Bush enacted under the war on terror and that Obama has continued to employ is the use of drones to attack regions where the U.S. military claims that enemy combatants reside. In this critical rendition of iconic black leaders, what could be more disappointing than a presidency on which so much hope was riding that does not follow in the footsteps of the political and cultural activists whose rhetoric and legacy Obama used liberally, but rather follows the path of previous presidents.

Perhaps no image captures the hope of many millions about the possibility of Obama's presidency and the letdown after his victory than Shepard Fairey's *Hope*. Fairey's portrait of Obama was designed for his first presidential campaign. Although the design was not part of official campaign materials, it became closely linked to Obama's run for president.

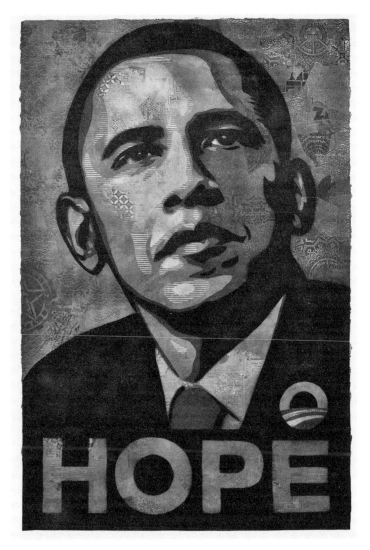

Figure 13. *Hope* by Shepard Fairey, based on photograph by Mannie Garcia of the Associated Press.

Fairey, a well-known commercial and street artist / designer, was inspired to make the poster because of the optimism he among many felt about Obama and the grassroots involvement that resulted in his victories. In *Hope*, Fairey takes a photograph by Associated Press photojournalist Mannie Garcia and renders Obama in red, white, and blue. Gone is the iconic and much-debated brown skin of Obama, and instead he is remade in the colors of the American flag. He is the ultimate patriot, made more transparent by how his campaign team remade the symbol and meaning of the American flag as the visual marker of his candidacy. One of the more interesting aspects of the *Hope* poster is how Fairey used his reputation as a street artist who has critiqued corporate messages and social conformism to promote a candidate to the highest levels of political power and establishment.

Fairey explains that he designed the poster initially with the word *progress* across the bottom but that he changed it to *hope* after the campaign contacted him and asked if he would be willing to alter it. Fairey consented out of enthusiasm for Obama's initial message, but he later expressed his disappointment with Obama's presidency. Moreover, the design became a source of controversy, which evolved into lawsuits against Fairey for copyright infringement and destruction of evidence. Fairey was accused of appropriating Garcia's photograph without crediting the Associated Press photographer. While Fairey claimed "fair use," he later pleaded guilty to criminal contempt for destroying and manufacturing evidence related to the case.[19] Over time, the poster has become an artifact of people's enthusiastic investment in the power of the racial icon, as well as a marker of many supporters' disappointment with Obama's political leadership and the promise of American democracy.

## THE FIRST FAMILY IN
## THE WHITE HOUSE

Even while President Obama has become a source of disappointment to many, he makes deliberate effort to perform and visualize his position as the upholder of the nation's greatness. One way is by returning to the strategic use of portraiture. Obama self-consciously portrays himself as the ideal father and husband of a picturesque nuclear family. In the 2011 official portrait of the first family by White House photographer Pete Souza, the Obamas convey unity and affection. Their arms are interwoven and they clasp each other's hands. They sit physically close. The first lady is positioned on one end and leans in on their older daughter, Malia. Mother's and daughter's heads gently touch. Michelle wraps her right arm around Malia's body, and they hold hands. On Malia's left side is the smiling president. His right hand holds Malia's left hand, as the father embraces the younger daughter, Sasha, on his left side. Sasha, the smallest of them all, stands and leans against her father. Their heads too touch gently. The smiles are big and illuminating. Their attire is dark and formal. In the background, we see a well-lit room in the White House filled with Christmas decorations.

The Obamas are an ascendant family. Modeling wholesome and inclusive values of the contemporary, nuclear, Christian family, they radiate achievement and fulfillment. Yet they are undeniably and assertively black. They have achieved, in this photograph, what most American families have not and cannot: first family; happy family of highly educated, dual-career parents; intact, nuclear black family; moral and ethical stewards of well-balanced children; photogenic and attractive; wealthy. Official photographs of this idealized twenty-first-century family are one of the techniques of image control and information dissemination that have become

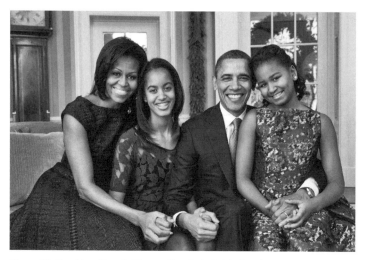

Figure 14. President Barack Obama, First Lady Michelle Obama, and their daughters, Malia (*left*) and Sasha (*right*), sit for a family portrait in the Oval Office, December 11, 2011. Official White House Photo by Pete Souza.

standard for recent presidential administrations. The particular forms that image control has taken in Obama's White House have received much media scrutiny. While Obama is touted as the first president to use social media and digital technology in his campaigns and as a personal user, he has also relied more on official photographers and offered only limited access to independent photojournalists. As one angry op-ed by the director of photography for the Associated Press argues, "Manifestly undemocratic, in contrast, is the way Mr. Obama's administration—in hypocritical defiance of the principles of openness and transparency he campaigned on—has systematically tried to bypass the media by releasing a sanitized visual record of his activities through official photographs and videos, at the expense of independent journalistic access."[20]

This deliberate sanitization is more complex than issues of presidential opacity. Since declaring his candidacy for the U.S. presidency, Obama's image has been under ruthless attack.

The July 21, 2008, issue of the *New Yorker* offers a striking example of this. Caricatures of Barack and Michelle Obama stretch the length of the cover. Michelle Obama appears unlike any photographic representation of her we have seen. Gone are the perfectly coifed hair, the fitted A-line dresses, and the sculpted biceps. Instead, on the cover, she dons a large Afro and holds a machine gun with several rounds of ammunition across her chest. She fist-bumps Barack, who is dressed in attire associated with Muslim men—a religious practice from which Obama has actively and problematically distanced himself, despite his early education in a Muslim country. The cover was widely condemned and hotly debated. As the descriptions and caricatures of Obama and his family have taken on more outlandish and exaggerated features, the president has continually represented himself and his family in the most normative and steadfast ways. This is quite striking given how widely images of Obama circulate in such varied contexts.

While Obama's attempts to control his image open him to critiques of hypocrisy and lack of transparency, his careful cultivation of image triggers a different register when read through the history of photography as a deliberative means of self-determination, group-identified aspirations, and racial uplift. This does not excuse or find a transgressive element in the Obama administration's control over his and the first family's image. Moreover, while black communities may understand more fully Obama's desire to control his image, the president has had a painful and vexed relationship with black Americans. He is willing and able to call forth historical wounds and to claim them as part of his personal narrative in opportune moments, and at the same time he and Michelle Obama have been on record making moralizing statements about "black deficiencies" that sound distinctly like a racial variant of noblesse oblige. The president and first lady have invoked a moral superiority and patronizing style often associated with

black religious and community leaders who have achieved educational and class privilege. The Obamas have admonished and even pathologized black working-class and poor communities for what they consider a lack of adherence to normative standards of nation, progress, and civil society.[21]

The Obama family, then, becomes a measuring stick used to guide and discipline black populations about the expectations and responsibilities of normative citizenship. The pose and poise of pictorial Obama leans heavily on earlier images of black male leadership from emancipation through the contemporary era. His singularity as the first black president is made a collective achievement of black Americans and international audiences, even as Obama critiques some of the very communities on which his elections relied. His family photographs, partly national propaganda, are also and always attempts to resist racist and sexist caricatures of black political legitimacy and prowess. The first black president as national icon is a vexed gift to black Americans and the nation more generally. Obama as community activist, Obamas as hopeful candidate, Obama as black man, Obama as mixed-race, Obama as two-term president, Obama as warmonger and deporter; Obama as father and husband: the assignations are seemingly endless, and yet the icon's multivalence is often overdetermined by its (hetero)normativity and (post)racial masculinity.

# Giving Face

## DIANA ROSS AND THE BLACK CELEBRITY AS ICON

DIANA ROSS ONCE STATED: "Icon. What is an icon? When someone is iconic it means they have established a certain kind of legacy possibly, and I think it does come with time. . . . I don't think you are born an icon." Her words restate a well-worn adage: one is not born a celebrity icon. Nor is one forced into the realm of celebrity iconicity as a matter of life or death (as many black political icons are). Instead, becoming a celebrity icon is a labor-intensive choice that involves sculpting one's features, developing public recognition, building identification, and turning one's self into a vehicle of desirability and adoration. In essence, the celebrity icon is manufactured and groomed. Yet even as Ross's words seem cliché, her statement reveals the level to which celebrity iconicity is an aspiration, deliberately sought out by those who hope to reach its heights.

Moreover, it is an investment made not only by the aspiring celebrity and entertainment industries hoping to capitalize but also by a willing public that ultimately judges whether one has reached this vaunted status. The celebrity icon's image is devoured and regurgitated by rabid fans, casual onlookers, and media producers. Envied and desired by many, she is the object of fantasy. She exists in hyperbolic terms. From the vantage

point of viewers and consumers of mass culture, this is not a fly-by-night affair, but an attentive engagement with a celebrity who has considerable longevity. A celebrity who reaches the status of icon, like Diana Ross, has secured this position by her standing and circulation beyond a specific talent, audience, or industry. The icon in the realm of celebrity represents a "staying power" and a public familiarity, even as she ages out of normative culture's standards of beauty and feminine desirability. At times, the term endows respect for a celebrity who is considered past her prime but who still compels audiences and engenders strong emotions, such as Cher, Lauren Bacall, and Iman.[1]

In American culture, the celebrity icon serves a variety of economic, cultural, and psychic functions. Historian Charles L. Ponce de Leon traces the rise in American celebrity culture to the development of human-interest journalism and news coverage of public figures from the late nineteenth century onward.[2] Ponce de Leon examines how journalists and reporters turned their pens and lens toward notable public figures as news stories, leading to the development of celebrity gossip columns. Relatedly, Leo Braudy, in his much-cited *The Frenzy of Renown*, links celebrity status to the rise and valuation of fame in various socio-historical contexts, dating back to early Western civilization (his examples include Alexander the Great, Cleopatra, and Julius Caesar).[3] In the modern era, the relationship between the iconic celebrity and the public "is one of the most intimate and far-reaching forms of sociability"; the celebrity, in this respect, is "an intimate doorway for connecting people."[4] This intimate connection between an anonymous and adoring conglomerate of fans and the inaccessible icon largely takes place through the realms of desire, fantasy, and aspiration. Sociologist Karen Sternheimer argues that one of the primary functions of celebrity culture in the United States is to mirror notions of the American Dream and social

mobility.[5] Moreover, the status is a celebration, and often an indulgence, in the expansive capacity of capitalism. From this perspective, the celebrity icon is recognized as a commodity and a consumer. Through her wealth and fame, she accumulates commodities with a hyperbolic appetite for more.

Diana Ross is one of the most photographed and adored celebrity icons of the modern era. Her fandom crosses several generations as well as cultural, racial, and gender affiliations and spans the globe. The making of Diana Ross as a black celebrity icon in the late 1960s / early 1970s, as she transitioned from being a member of the Supremes, is a fascinating case study in how the artist and her producers were able to incorporate certain racial markers of difference into her image and persona while simultaneously cultivating her as an exemplar of cultural assimilation, luxury capitalism, and mainstream acceptability. Of particular interest are the strategies that Ross and her production staff employed to develop her status as icon. These strategies include citing previous generations of black women musicians and entertainers and cultivating a signature photographic look that appeals to many fans across difference. Through these approaches, Ross-as-icon aestheticizes blackness to broad audiences and rehearses her arrival as a constant becoming, which keeps her fresh and relevant in an industry that capitalizes on youth, difference, and newness. Moreover, Ross provides a model and blueprint for black popular musicians and entertainers who follow her trajectory.

Much of her success can be attributed to her (ever-changing) look, documented in striking photographs that gained widespread attention over the course of her long career. In the early stages of her solo career, Ross released several press photographs that were central to launching her to new levels of stardom. As Adrienne Lai argues, official star photographs are important "to induce the consumer's desire for the celebrity and his or her products—in essence, they function as an

advertisement."[6] The style and composition of her publicity photographs, especially with photographers Harry Langdon and Victor Skrebneski, exemplify *giving face*, a mode of performance of *face* as an iconic form for modern celebrity. Giving face is a self-conscious and deliberate practice of elevating one's facial features through the conventions of celebrity portraiture, makeup, and lighting, with the intention of producing desire, envy, and idolization. It has been a signature form of image making for entertainers, especially women, since the rise of modern celebrity culture.

After leaving the Supremes in 1970, Diana Ross evolved into a groundbreaking, genre-defying solo artist, a model, an actress, a humanitarian, and one of the most photographed women of any race in modern history. Her career spans four significant decades from the 1960s civil rights era to the rise of Ronald Reagan and into the twenty-first century's digital and social media cultures. Historians and critics of black culture have analyzed the major shifts in American society and its long history of legalized racial oppression that marked this period. These changes include the civil rights movement's fight to end legal segregation, deindustrialization and white flight from urban communities in the 1960s and 1970s, the rise of conservatism, growing class cleavages in black communities, and attacks on the gains of freedom fighters. At the same time, the late twentieth century marks a period of rising black celebrity culture and the growth in black-owned entertainment companies. Thus Ross's rise to celebrity icon allows us to trace important developments in black politics and visibility and in the mainstream incorporation of aspects of black culture into American entertainment industries.

In a closely cropped photograph by Harry Langdon, Ross, in her mid-twenties and only a year or so into her solo career, is ready. She is fully present; the artist poses front and center. The minimalist, black-and-white portrait highlights the

Figure 15. Close-up of Diana Ross from *Blue* album photo shoot, circa 1972.
Courtesy of Harry Langdon.

artist's face through multiple borders that frame her head: the
cropped boundary of the photograph itself and her muscular
arms raised high and close to the contours of her cheeks and
hair. The grays of her skin tone, her dark coifed hair, the white
of her clothing, and her simple jewelry are meant to provide a
"neutral" backdrop to the artist's striking facial features. And

what cannot be ignored in this portrait are the shape, gaze, and mood of Ross's eyes. They peer out with intensity and fervor. Her gaze is both steady and directive, her vision both singular and comprehensive. Her signature long false eyelashes add a flair and whimsy to the intensity and self-possession of the artist (later known as "The Boss," also the title of her 1979 album). Ross's pose can be read as a response to a question that only she can answer at this moment: *How does it feel to be a black female icon, on top of the world, in the early 1970s, desired by many?*

We might think of Langdon's photograph as capturing a decade-long process of the making of an icon. The striking face presented in Langdon's portrait had been carefully cultivated and groomed by Ross and the Motown staff throughout the 1960s. Motown was created as a music recording company owned and operated by blacks whose mission was to develop and showcase black popular musicians. Berry Gordy, Motown's founder, was a leading figure in the revolution in popular music that garnered wide appeal among young audiences of different races and ethnicities. From the late 1950s through the 1970s, he built Motown into one of the most successful and lucrative recording labels of the era. Within a decade of its founding, Motown "became the largest black-owned company in America by selling the creations of other black Americans."[7] Among the label's most well-known musicians are Martha and the Vandellas, Smokey Robinson and the Miracles, the Four Tops, the Temptations, Stevie Wonder, Marvin Gaye, the Jackson 5, and the Supremes.

In the period that Gordy formed Motown, the country was in the midst of major transformation, in large part due to the civil rights movement. Civil rights leaders like Rosa Parks and Martin Luther King Jr. were household names. Given the social and political climate of change, Gordy deliberately used his company to produce music of integration. Motown transformed American popular music by taking the factory model

of Detroit's largest industry—automobiles—and applying it to music. Combining a model of production known as Fordism with the Hollywood studio and star system and the rich tradition of black performance, Motown developed some of the most successful and iconic popular musicians in American history.

Ross's and Motown's packaging of her image took place through a highly orchestrated process the company had devised to transform black musicians into crossover (and thus non-threatening) celebrity icons. In the 1960s, Motown was known as much for its look as its sound. The company promoted a public image that drew the attention of millions of young blacks and non-blacks in the 1960s and 1970s. It also manufactured black music and black appearance as endlessly pleasurable and accessible to multiple audiences in the United States and beyond. As music scholar Mark Anthony Neal explains, with Motown, Gordy established a company to execute a vision of "black progress in terms of the integration of mainstream and elite American institutions by blacks with highly textured middle-class sensibilities."[8] Under the songwriting and production of Brian Holland, Lamont Dozier, and Eddie Holland, known as Holland-Dozier-Holland, the Supremes released a record-breaking twelve number one hits, with songs such as "Where Did Our Love Go," "Stop! In the Name of Love," and "You Can't Hurry Love," in the 1960s. The group released twenty-five albums in less than a decade.[9]

Ross's face, how she gives and serves it in posed and candid photographs, is a carefully studied performance that dates back to her early days at Motown. Motown ran a finishing school as part of its artist development unit and created a well-oiled and successful system of cultivating black, crossover entertainers. It took its cues from Hollywood. As former Supremes member Mary Wilson explains in her memoir: "Motown's Artist Development department was patterned after the movie studio

'charm' schools of the thirties and forties. In the sixties, when most young performers were rebelling against show-business conventions, Motown's approach seemed archaic."[10] In the late 1960s, during the rise of many of the company's biggest stars, Maxine Powell oversaw this unit. Powell arguably was as important to the success of many Motown artists as Berry Gordy, and the company's highly regarded songwriters and producers were. Powell had decades of experience in the black beauty and image industry. Before coming to Motown, she had worked as an actress, run a modeling agency, and trained as an aesthetician at Madam C. J. Walker's School of Beauty Culture. When Powell died at ninety-eight in 2013, her obituary in the *New York Times* quoted Diana Ross as stating that Powell was "the person who taught me everything I know."[11]

Through the labor of Powell and others at Motown, Diana Ross was groomed for stardom as a high school student when she and the original members of the Supremes, then called the Primettes, signed to Motown in 1961. Her transformation included changing her name from Diane Ross to "the more theatrical and sophisticated Diana Ross," which was "one of many calculated image-making moves that in 1964 would change the Supremes from a diligent, rather juvenile trio into the epitome of upwardly mobile, adult bourgeois charm."[12] In the Motown system, artists were molded, sometimes against their stylistic preferences, toward a mainstream acceptability, one that refuted notions of black excess. Nelson George writes: "She [Powell] cautioned the singers not to protrude their buttocks on stage, feeling that it was like telling the audience to kiss their ass. She was also fanatical about acts not standing with their legs wide open. If you had to do a naughty step (which wasn't really necessary anyway, she felt), it must be done pleasantly and not draw undue attention."[13]

### ROSS AND THE ICONIC
### FACE OF CELEBRITY

In photographing Diana Ross and other celebrities, Harry Langdon takes many of his cues from cinema and celebrity portraiture of Hollywood's golden era. Film theorist Richard Dyer argues that cinematic scale ("the big pictures") and aesthetics (Hollywood glamour lighting and familiar dramatic narrative) are the dominant lens for framing celebrity in twentieth-century culture.[14] Through the rise of cinematic culture, we witness the emergence of fandom and the fetishization of the "face-object," as French theorist Roland Barthes analyzes in his influential essay "The Face of Garbo."[15] Since cinema's early days, the performance of face has been a quintessential feature of the celebrity as icon.[16] Photographs of celebrities often focus on facial features, especially the eyes, cheekbones, and mouth. Hair pulled back and lights set to highlight its contours, the face is removed from the body and floats in a manner that further serves the idealization of the icon. In Barthes's meditation on Greta Garbo's beauty and her face as cinematic fetish, another important revelation about the power of the popular medium to deify emerges: that is, how whiteness serves as the chromatic default for the idealized face of the celebrity. In his fetishization of the whiteness of Garbo, Barthes writes of the "flour-white complexion" of the starlet's "snowy solitary face."[17]

Taking into account the normalization of beauty as white, we then see that one of the major effects of the black celebrity as racial icon is a disruption of iconic whiteness through another staging of face, as photographs of Ross demonstrate. Ross is noted for the cultivation of her iconic face and for producing a cross-racial and gender-varied desirability. Nelson George, in examining Motown founder Berry Gordy's obsession with Ross, his ex-lover, writes that Gordy was captivated by Ross's

"eyes as luminous as silver dollars on a poker table, a mouth as wide as her face, projecting an urgent desire to please."[18] Langdon once exclaimed: "Baby love those eyes! She is and always will be pure, sublime inspiration. Diana is one of those surreal subjects that came before my camera and catapulted my art into unexplored creative realms. With her famous lithe figure and dazzling smile, Diana lights up her photographs and her audience. She soulfully invokes love, romance, and the desire to dance."[19] Here and elsewhere, Ross's features are described hyperbolically and in highly feminized terms.

Moreover, the performance of cinematic face that Ross mastered has served as an aesthetic for other black celebrities, entertainers, and countercultural performers. For example, queer ball scenes have been a well-documented site of giving face and staging cinematic glamour. Giving face, and also serving face, is a dialectical performance in which gestures, signs, poses, and cues respond to other performers and audiences. Ross seems acutely aware of her performances as phenomena. For example, her 1980 hit song "I'm Coming Out" was partly created in response to New York drag queens who performed as Ross, including adopting her signature facial gestures: raised eyebrows, pursed lips, and sculpted cheekbones. In this instance, Ross's cultivation of her iconic status includes intimate and strategic responses to her fans. Moreover, giving face has evolved as various performers and fans have taken up and modified the form and as new counterpublics emerge with divergent notions of fandom and desirability. Within black vernacular and expressive cultures, to give face is a mimetic engagement with and transformation of the mythos of cinematic glamour and resonates beyond celebrity.

One of Ross's more diffusive and yet impactful legacies is her cultivation and embrace of a queer iconicity. This partly refers to Ross's embrace of an urban gay fan base and a longer and complex tethering between black women and gay men of

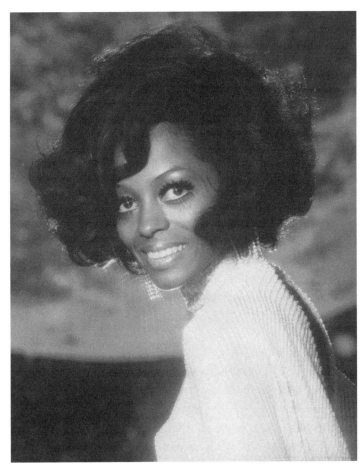

Figure 16. Diana Ross, moon backdrop, early 1970s. Courtesy of Harry Langdon.

various races. Ross's practice of queer iconicity goes beyond fandom and connects to an affective performance of sensuality, recognition, and love that she practices in her solo career. What I mean by her queer iconicity is an affinity, an aesthetic, a sexual exploration, and notions of belonging that Ross engaged, moving her far beyond the heterosexual romantic sensibilities of her earlier career. Ross promoted a post–civil rights, gender-fluid love ethic that was integral to her growing status

as a solo star and that was later adopted by Michael Jackson, Luther Vandross, Janet Jackson, Jody Watley, Celine Dion, and other solo stars. In the second half of the 1970s, she became known for her experimentation with disco and moved further away from her Motown upbringing. During this period, Ross was known to frequent Studio 54 and to associate with Andy Warhol, Nile Rodgers, and many in New York's downtown scene. The cover of her 1982 album *Silk Electric* was designed by Warhol and is another example of her demonstrative self-conscious performance and exploration of her iconicity as a black female celebrity in the civil rights and post–civil rights eras. On the cover, Ross looks over her unclothed shoulder, her hair draped to the other side. Her eyebrows are arched, and she looks out intently; her lips are closed and painted a shiny red. Gone are the fitted matching gowns and perfectly coifed wigs; they were replaced with long flowing wigs and unstructured, revealing clothing.

## Ross and the Legacy of Black Entertainment

Ross and her handlers had a sharp attunement to how racial iconicity hovered in the tensions of veneration and denigration. As a result, Ross's public persona played with and against dominant images of celebrity by incorporating codes of Hollywood glamour into the aesthetics of more politicized notions of blackness. Consider a photograph from Ross's photo session for her 1971 album *Surrender*, one of several albums released in a year's time to establish her as a solo recording and performing artist post-Supremes. The airbrushed and glowing photograph is significant for its style and politics. Here Ross sheds the sequin dresses and bouffant wigs that characterized the girl group for a more sensuous and racially inflected image that spoke to the cultural and political mood of the early 1970s. With one bare shoulder foregrounded by a flower-print wrap,

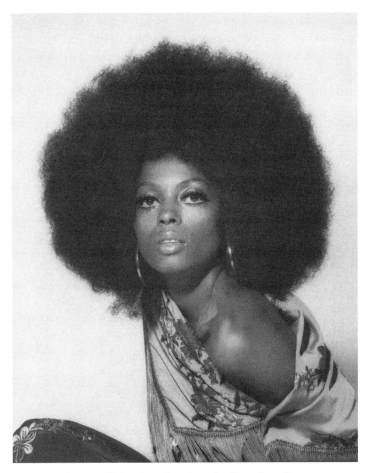

Figure 17. Close-up of Diana Ross from *Surrender* album photo shoot, 1971. Courtesy of Harry Langdon.

Ross stares out with a steady and purposeful gaze. Her signature long eyelashes frame her eyes, and her face is angled to highlight her cheekbones. Her mouth is slightly open, a gesture of relaxed comfort, self-assurance, and receptivity. Her large Afro wig takes up sizable space in the composition, and shiny, large-hoop earrings, popular among black women during the era, provide contrast and definition for the wig.

In this photograph, Ross embodies the slogan "Black is beautiful" and yet capitalizes on the celebrity and success that she achieved in a crossover female group whose aesthetic appeal was cultivated to please and seduce, but not unsettle. Black cultural critics have examined the shift toward black aesthetics among black musicians and entertainers in the 1970s. The Black Arts movement and the black public's embrace of "Black is beautiful" pushed new visual signs and fashion into broader circuits of American media and public life. As Diana Ross's solo career grew throughout the 1970s, she continued to incorporate markers and signs of black culture and style into an ever-expanding and globalizing musical sound and iconic status. This particular photograph speaks to another, more politicized and polarizing image during the exact same period: Afro-coifed Angela Davis as professor, black feminist radical, and fugitive from the law.

In 1970, Davis, a well-known philosopher, freedom fighter, and public intellectual, was placed on the Federal Bureau of Investigation's (FBI) ten most wanted fugitives list after she was accused of being an accomplice in a politically motivated murder and kidnapping. Davis, who was tried and acquitted of any involvement, has written about the representation of her Afro and style during that period. She discusses the ethical violation of seeing her image serve various commercial and political purposes over which she had no control (from wanted posters to representations of her as a charismatic revolutionary). Davis explains how the attack on black radical and progressive thinking and style during the era subjected many, Afro-wearing black women to routine stops and searches by law enforcement. Yet she notes as well how the Afro has become aestheticized and depoliticized as fashion and style for consumer culture.[20]

Considering the rise of Diana Ross as a solo artist in conversation with black radical politics and intellectual work

during the era, it becomes clearer how Ross appears as racially aestheticized and politically nonthreatening in normative American public culture. In this regard, Mark Anthony Neal contextualizes her solo career in relationship to the development of black feminist studies, writing: "Diana Ross served as the commercial icon who would deliver Motown into the next phase of its development. By chance, Ross's emergence as solo artist coincided with the development of the first major body of black feminist work. Devoid of any particular political or racial agenda, Ross nevertheless came to represent the full articulation of black 'diva-hood' for a generation of young divas in the making."[21] At the same time that an Afro-wearing Ross glistened on the cover of her album, another well-circulated image of the period was an Afro-coifed Davis as the subject of the "Free Angela and All Political Prisoners" campaign.

This juxtaposition illustrates how context shapes interpretation of racial signs. What reads as radical, and even criminal, on a FBI wanted poster is an aesthetic and seductive prop (an Afro wig that for Ross can be removed) of both racial difference and mainstream access. Beyond the Afro, the portraits are composed of different signs and strike different registers. Davis's photograph is involuntary; it is a mug shot, a form of portraiture produced by the state to index criminal suspicion. By contrast, the photograph of Ross is meant to entice and seduce a broad audience into the orbit of her fandom.

Ross has been criticized for her mainstream appeal and lack of an explicit political stance, although this criticism overlooks her insistence on working with black record labels, songwriters, and producers and mentoring younger black entertainers. Because celebrity is interwoven into capitalist accumulation, the intensified forms of recognition that come with fame, and shifting notions of value, black celebrity is a fraught category. Achieving iconic celebrity status has come to represent a gauge of racial success, but particularly in the post–civil rights era

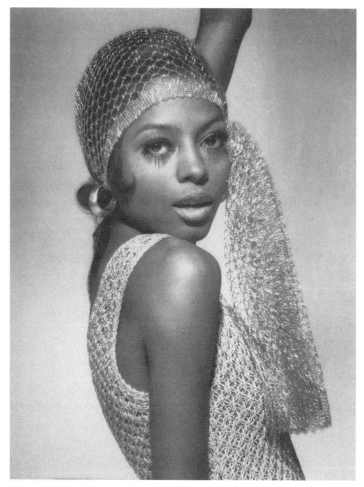

Figure 18. Diana Ross wearing scarf, early 1970s. Courtesy of Harry Langdon.

and with the growth of a black entertainment industry. Even
more so, black celebrity is meant to be exemplary of capi-
talistic meritocracy and American democracy's promise that
anyone, through hard work and ingenuity, can achieve wealth
and fame. As Sternheimer argues, "Celebrity culture seems to
provide a continual reaffirmation that upward mobility is pos-
sible in America and reinforces the belief that inequality is the

result of personal failure rather than systematic social conditions."[22] Hence, in some respects, contemporary black celebrity is the quintessential marker of both American capitalism and civil rights achievement. Black celebrity thus mirrors what normative and racist American culture frames as black underachievement (i.e., high rates of poverty and unemployment, indebtedness, mass incarceration, and lower educational rates).

At the same time, there are distinct characteristics of black popular culture that are important to keep in mind when considering the black celebrity as racial icon. The rise of a black celebrity, no matter a specific artist's or entertainer's class or regional beginnings, tends to be read within a representational space of negation. Stated otherwise, the black celebrity icon operates in relationship to or against the limited access that blacks have had historically and presently to arenas of power, wealth, and possibility. Moreover, the black celebrity has to contend with commodity fetishization on a heightened level given the history of slavery and black bodies as commodities to be bought, sold, and exploited.

In addition, the black celebrity is read through a long and impressive history of black entertainment culture, with roots in the exploitation of black expressive practices during slavery, after emancipation, and into the contemporary era. Cultural historians have documented various traditions and practices in black expressive culture that have widely influenced American entertainment industries; minstrelsy, blues music, jazz, gospel, rap, and black dance forms have been analyzed on a spectrum ranging from coercion to resistance. Even those practices that are widely understood as practices of coercion, such as performances for slave masters or all-white audiences, are understood to have multiple meanings.

Another consideration is that many black artists, activists, and critics have been concerned about how to represent blackness in the public sphere throughout the twentieth century and

into the twenty-first century. We can look at various artistic movements and cultural practices as composed and calculated modes of visibility. Since the 1960s, there has been a growth in black-owned entertainment companies, Motown being one of the most successful. At the same time, the representational value of the black celebrity icon is more unstable now than in the past as the risks and rewards attached to this status have heightened. In these rarified arenas of black superstardom, what does it mean to be envied when one's racial group has spent centuries being despised, devalued, and exploited? Because of the difficulties arising from this question and the muddied terrain that the black entertainer must journey, black celebrity culture is always already a politicized and ideological arena, whether the performer likes it or not.

While the celebrity icon functions differently in many ways than the political icon of modern democracy, celebrity culture and politics have historically been intertwined for black public figures. Especially during the height of the civil rights movement, many black celebrities were active in organized demonstrations and outspoken in their stance against racial injustice and segregation. In more subtle ways, black celebrities used racially inflected fashion and visual signs to mark their racial identification and belonging while circulating in broader spheres of U.S. entertainment industries, as was the case for Diana Ross in the 1970s. Her appeal deeply relied on her ability to aestheticize black cultural and political traditions in ways that were seductive, idiosyncratic, and seemingly nonthreatening to a massive spectrum of fans. For this reason, Ross has been described as "the epitome of pop music to the world."[23]

Yet despite being promoted as singular and exceptional, Ross has been vocal throughout her career about how she benefited from previous generations of black entertainers. As she recognizes, many black female entertainers who came before

her, such as Lena Horne, Billie Holiday, and Dorothy Dandridge, paved her pathway to stardom. In her memoir *Secrets of a Sparrow*, Ross speaks openly about her indebtedness to early performers:

> My life and career were made easier by others who suffered indignities and stood up to certain abuses. I'm talking about such women as the great contralto Marian Anderson, the gracious Lena Horne, the inspirational Ethel Waters, the fragile and vulnerable Dorothy Dandridge, the brave and exotic Josephine Baker, and scores of others: Billie, Bessie, Sarah, and Ella.
>
> There are scars, and there are also small victories. Still, I know that as a black woman, I remain in bondage. I know that all black people do, in spite of the tremendous advances we have made over the century. That's because the one thing none of us has been able to destroy completely is hate. If God gave me one job in life, it is to help a world in which we are all just people.[24]

While the memoir is not meant to be challenging reading or sober in tone, Ross pointedly addresses the continued struggle against racial oppression (using the powerful term *bondage* to signal injustice). She also makes a strategic move to align herself with black communities and to signal her core audience/reader as black through the invocation of "we."

Ross embodies musical history and her racial and gendered legacy through performing as earlier entertainers as a mode of paying homage. One notable example is her identification with Josephine Baker, who was one of the most famous women in the United States and Western Europe in the early twentieth century. Baker, a black American dancer who in 1925 migrated to Paris and there found international fame, is best known for sensational performances that played with notions of racial primitivism and sexuality. A great deal of Baker's success is a

result of her wide popularity among white Europeans and the iconography that she cultivated: the banana skirt, a pet chee-tah, and nudity as costume.

Ross sees in La Baker a muse for her own creative explo-ration and myriad looks. She has spoken of and has performed her admiration of the earlier star, such as in her 1977 Broadway show and television program *An Evening with Diana Ross*. Ross has also staged photo shoots in which she has re-created some of Baker's most iconic looks. Ross proclaims in the photo-graphic collection *Diana Ross: Going Back*:

> La Baker! Courage on top of talent. Vision, too. Trusting herself enough to be a little outrageous, I have always loved Josephine. Her love of children is merely one tie that binds.
>
> I never had the chance to make the movie of her life, and that is a lost dream. But nothing was lost, nothing wasted, from all that I learned about her charismatic life while I was pursuing that dream.
>
> "I shall dance all my life," she said. "I was born to dance, just for that."
>
> I cannot stop—Josephine could not stop.[25]

In many respects, Ross's connection to Baker might seem obvious—black female entertainers with wide crossover appeal, both masters of self-fashioning (Baker as "La Baker" and Ross as "Miss Ross"). Furthermore, they are both known for modes of racialized eroticism in their performances and public personae. Yet I would like to pull a strand from theorist Anne Anlin Cheng's study of Baker and modernism to under-stand the significance of Ross as a black celebrity icon. Baker serves as an important lens through which to see Ross's iconic status with even more clarity. Cheng writes: "Celebrated as icon and decried as fetish, Baker has been viewed as either a groundbreaking performer or a shameful sellout. Instead of resolving these tensions, I am more interested in the challenges

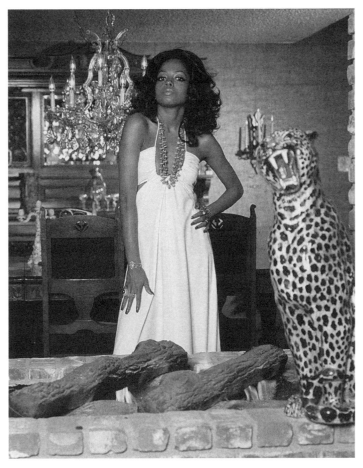

Figure 19. Diana Ross with cheetah statue, 1979. Courtesy of Harry Langdon.

to the politics of the visible that her work and legacy pose."[26] For most black celebrities who reach the cross-racial popularity of Baker and later Ross, such issues of exploitation and cultural authenticity often overshadow other interpretations and ways of registering their impact.

Most notable among Ross's rehearsal of black women's musical history is her starring role in the film *Lady Sings the Blues*, a biopic about Billie Holliday. While Ross studies and

invokes black women's musical and performance legacies to ground her work, her restaging has been described and interpreted by dominant American culture as marking a racial progress that allows Ross to reach the heights that her predecessors could not. In a profile published in *Life* magazine in 1972 before the release of *Lady Sings the Blues*, Ross is depicted in a supportive and luxurious environment, surrounded by her parents, her white husband, Bob Silberstein, and her longtime producer Berry Gordy. The journalist makes every effort to compare Ross to the late Holiday. Noting that both artists grew up poor in black communities, the writer is clear to mark Ross's triumphant narrative as distinct from the embattled Holiday: "When it came time to begin her career, she had Berry Gordy to watch over her like royalty. 'On the road we weren't allowed boyfriends and no one went out alone,' she recalls. Again unlike Billie, who was always broke, Diana was a millionairess at 25. Now, married to Robert Silberstein, who is white and a public relations executive, with a new baby and a fine home in Beverly Hills, Diana Ross has secured all that society denied Lady Day—including an assured future as a singer who is also an actress."[27] The article is accompanied by a series of photographs, including one of Holiday from 1957 next to an image of Ross posing as the late singer. A large colorful photograph of Ross with her hair styled in an Afro and leaning on her husband has the caption, "Seated on the floor of her sunken living room, Diana relaxes with her husband, Bob Silberstein. Although elaborate wigs are her trademark (see cover), she often goes without one at home."[28]

Farah Griffin in her study of Billie Holiday troubles the association between black female entertainer and tragedy that has long framed black women as public figures.[29] Ross, in performing Holiday and other black cultural figures, often invokes the tragic narrative of black female entertainers exploited by white and patriarchal powers in the entertainment industry. In

doing so, though, she performs this important disassociation to gesture toward the complexity of black women's performance and musical significance to American culture. More precisely, Ross uses these moments of restaging to honor the talents of other black women artists but via a constant reimagining of her iconic status. These performances become opportunities for Ross to explore the aura and limits of black celebrity. Each event serves as another moment of becoming and arrival for Ross.

As she cultivates herself as a post–civil rights celebrity icon, she also strategically challenges normative assumptions about black female desirability and features. Her music of the 1970s and 1980s also enacts a counter-performance to tragedy and stories of woe by narrating black female desire, self-determination, and power. This is most crystallized in her solo career with songs like "Reach Out and Touch" (1970), "Love Hangover" (1976), "It's My House" (1979)," "I'm Coming Out" (1980), and "Muscles" (1982). She seamlessly moves from one look to another and experiments with new genres, fashion, scenes, and aesthetics, while remaining indelibly "black" and committed to an articulation of her roots in black Detroit. In her mastery of black performance traditions and American celebrity customs, Ross achieves a status of veneration by her legions of worshipping fans in large part due to her ability to aestheticize features of blackness as desirable and consumable.

We witness a visually significant marker of Ross's cultivation of celebrity face and black female desire/desirability in a Langdon photograph from 1975. At this point, Ross is secure in her solo career, having released several albums and launched her film career. In this publicity photograph taken during the time that Ross's second film, *Mahogany*, was released, she gives a performance of face strikingly different from that in previous images. In this shiny, glittery, full-body image, she is subject and background. In a body-clinging, lustrous gold dress, she

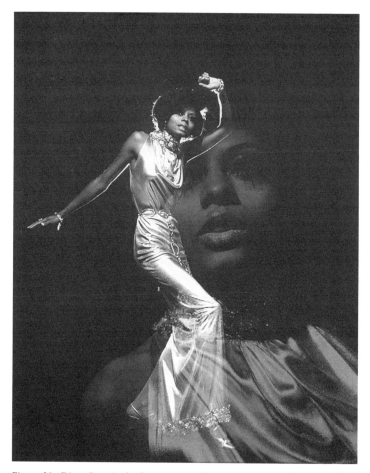

Figure 20. Diana Ross in the foreground and background, 1975. Courtesy of Harry Langdon.

strikes an action pose. One arm swings above her head, the other points behind her. She steps forward with knees bent, as if in the middle of a dance step. Her lips are separated, but her expression is not quite a smile. It is more an expression of self-composure, of concentration. This full-bodied shot is overlaid on another image of Ross from the same shoot. The muted backdrop is washed with a slightly red filter and consists

of an oversized image of her face and chest. The backdrop touches against the side of her body in the foreground. Ross's larger-than-life iconic face serves as her own tableau for further exploration of her iconicity, of her power to demand our attention.

Diana Ross, without a doubt, has been an enormous trailblazer for black popular musicians throughout the late twentieth century and into the twenty-first century. She has been credited with mentoring and parenting many younger black musicians, most notably the Jackson 5, growing especially close to Michael Jackson. Moreover, fans of popular culture can recognize not only her musical but also her stylistic influences, from the extravagant wigs, to the Broadway costumes, to her ever-changing look and scene—in entertainers like Stephanie Mills, Janet Jackson, Madonna, Mariah Carey, Jennifer Lopez, Beyoncé, and many more. The legacies of her expansive sense of belonging, loving, and glamour can be seen in the contemporary black musical icon Janelle Monáe, whose sound crosses genres and whose look combines classic Hollywood, Motown, and gender-bending camp.

Ross did not secure her iconic status as a black celebrity through a total embrace or rejection of dominant notions of American beauty, femininity, and glamour. Instead, she carefully cultivated a myriad of looks and possibilities for living, loving, and becoming that appeal to one of the broadest ranges of audiences—to the American public in an expansive sense. We hear this celebration in one of her most well-known songs, "I'm Coming Out," written and produced by Bernard Edwards and Nile Rodgers. The song has been remade, embraced, and lip-synched countless times; it has served as an anthem for many living on the fringes and margins of American society. In her performances, Ross would sing this song as she entered the stage. The chorus was heard before the icon was revealed. Then miraculously, she would sashay through aisles of fans in

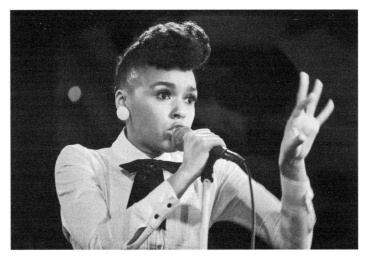

Figure 21. Janelle Monáe, Black Eyed Peas Peapod Foundation Benefit Concert, Los Angeles, 2009. Image by Mark J. Sebastian—www.markjsebastian.com.

a shiny, long gown and white fur coat. She hugged and kissed fans as she walked onto the stage. Then she would perform total jubilance, swinging her microphone, tossing her hair, and smiling a radiant smile as she gave face. Her audience would sing along with her. As performed and embodied by Diana Ross, being an icon is a labor of love that the many millions can cultivate in part through giving face, a bold, fearless invitation—a challenge, at times—to be recognized. Yet hovering in the shadows of her celebration of self and audience, in her claiming of love and recognition, is the haunt of the devaluation of black life, aesthetics, and talent. The veneration of Ms. Ross—the face, the eyes, the fashion, and voice—is the quintessential story of a black star who rises above circumstance.

# The Black Athlete

## RACIAL PRECARITY AND THE AMERICAN SPORTS ICON

PERHAPS THERE IS NO other sector of culture and commerce where the legacies and practices of chattel slavery are more explicitly invoked in the contemporary era than the lucrative and highly elite world of professional sports. From the ritual of the draft by which many athletes enter professional team sports to the periodic trade and the declining value of the aging body, the fundamental roots of racial capital are interwoven into the seemingly meritocratic and voluntary markets of athletics. As the vestiges of slavery cast a shadow on contemporary sports, commentary on the features, strengths, and weaknesses of the body—very often the masculine black body—is routine public discourse. Beyond market assessments on athlete's performance, sports commentators regularly fetishize the black athlete in gleeful, erotic ways (e.g., "He's a stud!"). We audience members and fans are a crucial party in the contractual agreement that regulates the value and usage of human (and other animal) bodies in athletics. Because of the particular emotional and financial investment of fans in athletics, the racial icon in sports registers differently than in other sectors of entertainment culture.

Over the past century, a complex, laden relationship between black athletes and American media and audiences

has heavily influenced the business of sports. A brief history of the black professional athlete as American cultural icon in relationship to racial politics and capitalism helps make this relationship clear. Moreover, the massive campaigns to corporatize, brand, and market superstar athletes as global commodities since the 1980s only highlight the tensions between black athletes and American capitalism. In particular, the growth in the sports industry has led to hyper-scrutiny of the career profile and decision making of superstar athletes, especially the career choices, personae, and seeming public errors of black athletes. The fraught and sensational reception of two contemporary athletes—Serena Williams and LeBron James—illuminates the shifting dynamics of race, gender, corporatization, and superstar power. In looking at these two figures, the particularities of racial iconicity in sports where blacks have been valorized, fetishized, and rendered as threats for their athletic prowess become apparent.

## The Politics of Black Athlete as Racial Icon

American public awe of black athletic success is a long and checkered history. Pioneer boxer Jack Johnson remains an emblematic figure in the history of race and sports and in unraveling the connections between athletics, sexuality, and the demonization of black men in the United States. Johnson, the child of former slaves, was one of the most famous Americans in the early twentieth century. Rising to prominence at the same time that the modern celebrity industry emerged, Johnson became one of the first black American celebrity athletes.[1] His fame was partly a result of his unprecedented achievement in the boxing ring, as "the first black man to win the heavyweight championship."[2] Outside the ring, Johnson lived a highly public life in which he enjoyed the wealth and fame of his sporting career and openly dated and married white

women. Performance theorist Harvey Young emphasizes the different reception of Jackson among black audiences and white ones, writing: "If his plans called for a stop in Chicago, or any other large city with a significant black population, then the [black] press would tell its readers where and when to welcome the champion. Consistently, thousands of black spectators would attend these welcome and send-off events."[3]

However, whites saw Johnson as a threat, flashy and indulgent. Young continues: "Equal to the esteem given Jack Johnson by blacks was the loathing directed toward him by many whites. To them, 'Jack Johnson' represented the most detestable traits of the black race. He was arrogant and flashy, and his desire for white women established him as a threat."[4] As a result, Johnson was arrested in 1912 and convicted for violating the Mann Act (White Slave Traffic Act of 1910) when he crossed state lines with one of his former girlfriends.[5] His deliberate eschewing of the limitations placed on blacks during the era and his willful and pleasure-driven attempts at self-determination transformed the boxer from a threat in the boxing ring to a boding menace to white male supremacy. Johnson's notoriety and his iconic status resonated for generations, long after the height of his career.

Considering the significance of Johnson in the early twentieth century, Young analyzes an important link between the bodies of black athletes and the history of captivity of blacks as slaves. Johnson emerged as a celebrity only a few decades after the legal end of slavery, during the period of Jim Crow segregation. Young notes how Johnson, similar to enslaved black boxers who had come before him, "was repeatedly displayed as an object for amusement and even potential financial gain for others." As he became increasingly aware of his status, the prizefighter "actively sported his own body for financial gain. Through performance, a performance of himself as a body on display, the prizefighter asserted control over the presentation

of his body."[6] Sports historian Theresa Runstedtler similarly examines how Johnson self-consciously promoted himself both during and after his professional boxing career. By 1933, the aging icon "had become a kind of museum piece as he 'boxed' with youngsters in Dave Barry's Garden of Champions at the Chicago World's Fair."[7]

Johnson's career and legacy are testament to the distinct and complex positions of black athletes in American culture. On the one hand, sports have been touted as a clear and definitive arena where black achievement can be "objectively measured" and, indeed, where individual acts and successes become symbolic of collective progress. On the other hand, the struggle for blacks to integrate professional athletics and to establish lives of their own making, within and outside of the sports world, has been a recurring source of public drama, a familiar cultural narrative of success and failure played out on various media platforms. In essence, black integration of professional athletics has been interpreted in two dominant frameworks: representational politics and racial achievement. For example, in team sports, historical accounts of baseball as "America's national pastime" often focus on the impact of Jackie Robinson, the first black player in the major leagues, who joined the Brooklyn Dodgers in 1947. While recognized for his skills on the playing field, Robinson also became an iconic symbol of racial integration; the quiet, respectable man who refused to be driven to rage even by the racist taunts of fans and fellow players appealed to a broader public and national narrative of progress. This framework continues to dominate the discussion of professional athletics and public acceptance, from the rise of Tiger Woods in golf, to the growth of black coaches in the National Basketball Association (NBA), to the lack of black ownership in the National Football League (NFL).

Another crucial framework for analyzing the black sports icon, historically, is as a "race man," an overtly and deliberately

politicized figure who uses athleticism to challenge white supremacy. In this framework, the black sports icon represents racial achievement and serves as a counterweight to the forces of racial subjugation. Paul Robeson is literally and figuratively a giant in this genealogy of black sports accomplishment. Robeson integrated the Rutgers University football team in 1915; he was twice selected a first team All-American and was accomplished in other intercollegiate athletics. In addition to his storied sports career, he was an accomplished singer, orator, and actor. As a stage actor, he performed in *The Emperor Jones* and *All God's Chillun Got Wings* and played the lead role in *Othello* in New York City and in England. Emerging during the rise of cinema, Robeson also starred in the masterpiece *Body and Soul* (1925), directed by pioneer black filmmaker Oscar Micheaux. Known for his intellect and skilled performance in multiple arenas (performing arts, sports, scholarship), Robeson was also widely admired for his bodily form. Theorist Hazel Carby examines how during the height of his career, he was represented by white and black critics and audiences alike as "a national icon"; he was idolized for his many talents and his physique.[8]

In 1925, Robeson posed for a series of nude photographs for portrait photographer Nickolas Muray in Muray's Greenwich Village studio. Carby theorizes:

> To modernist imaginings, Paul Robeson offered the possibility of unity for a fractious age, while he simultaneously embodied what the dominant social order imagined to be an essential "blackness" or "Negroness." Through this alchemy of the elements of classicism, a utopian representation of Robeson's body evolves as a prescription for the healing of the historical rupture of the nation between North and South. The cultural projection of meanings onto Robeson potentially applied to all black men because he was also

represented as a symbol: "A sort of sublimation of what the Negro may be in the Golden Age"; or as an embodiment of "the very accent and spirit of . . . Negro laborers."[9]

Robeson, who was once idealized as a symbol of national healing, was demonized in his later years as an enemy of the state by politicians, white mainstream media, the black conservative press, and theater audiences. As Robeson's political views evolved, he became a staunch antiracist activist and participated in several international leftist alliances against militarism and fascism. Because of his activism, he was blacklisted and investigated by the House Committee on Un-American Activities in 1956. His passport was revoked by the State Department, and many of his concerts and public performances were canceled. Robeson, once idolized, became shunned by many. Still, he continued to advocate for human rights and to build international alliances with oppressed groups, garnering admiration among progressive black Americans and leftist activists. Robeson's legacy continues to loom large and is a powerful example of how various publics make use of racial icons at different historical and political moments.

In the 1960s, black athletes such as Hall of Fame boxer Muhammad Ali and Olympic runners Tommie Smith and John Carlos experienced similar ostracism and public hostility, especially from many non-black Americans, because they used athletic platforms to fight for racial justice. In 1968, Smith and Carlos staged one of the most iconic photographs of the twentieth century. During the Summer Olympics in Mexico City, Smith and Carlos, representing the United States, ran in the 200-meter race, with Smith setting a new world record and earning a gold medal and Carlos winning the bronze medal. Smith and Carlos used the Olympic medal podium to perform a strategic enactment of black power. Australian runner Peter

Norman, who won the silver medal, sympathized with Carlos and Smith's protest. All three wore human rights badges as they stood to receive their medals. Carlos and Smith then raised their gloved fists in the Black Power salute. They offer compelling examples of political activism by black athletes in the 1960s and 1970s.[10] But in this case as in others, black sports icons were punished by respective sports associations and the mainstream American public for bringing freedom struggles and civil rights activism onto the playing field.

### THE MICHAEL JORDAN EFFECT: MAKING THE MODERN CORPORATE SPORTS ICON

From the segregationist hysteria that Johnson confronted in the early twentieth century, the anticommunist witch hunts that ensnared Robeson in the 1950s, and the progressive anti-war and pro-black politics of the 1960s and 1970s that Smith, Carlos, and Ali exemplify, the arrival of Michael Jordan to the NBA marks a very different era of race and professional sports. That Jordan forever changed the relationship between black athletes, commercialism, and professional sports is not an understatement. In 1984, the Chicago Bulls drafted Jordan after a very successful college basketball career at the University of North Carolina at Chapel Hill. He played a highly athletic form of basketball marked by gravity-defying jumps, long and clean balletic lines, and highly entertaining slam dunks. In the cultural imaginary, Jordan is the quintessential black athletic icon performing superhuman feats that were as much spectacle as sport. During his industry-altering, pathbreaking career, he won five league Most Valuable Player (MVP) awards and six NBA finals MVP awards and led his team to six NBA championships. Jordan garnered immense fan worship from audiences nationally and internationally. He literally is described in godlike terms and is represented as such in posters

and advertisements, such as the popular Nike "Wings" poster of the athlete with outstretched arms.

Arguably, Jordan's greater impact on professional sports took place off the court. One of the lasting legacies of the NBA Hall of Fame star is the wedding of the celebrity athlete with American capitalism. Jordan embraced modern athletics as a capitalist enterprise to a degree that no other black athlete before him had. This is not to say that sports and capitalism were separate entities before his arrival; sports are a moneymaking venture. In addition to the capitalist ventures of teams, leagues, and associations, individual athletes have long endorsed various products, from cereal to insurance to underwear and so forth, for pay. Yet the corporate endorsements of Jordan and his partnership with various businesses transformed the relationship between modern sports, audience, race, and capitalism. Norman K. Denzin writes: "Michael was everywhere. And Michael and [David] Falk [his agent] saw this coming; indeed, they helped make it happen. The audience was huge, and just keeps getting bigger. In turn, the internationalization of Nike, Coke, and McDonald's overlapped with the rise of the sign of MJ. And this sign of MJ was one that would sell globally, the gentle, kind, warm, dependable, wholesome, authentic, family man; the man for all seasons."[11]

Under the reign of Jordan, basketball went global through the expansion of the sport, athletic apparel (especially sneakers), and racial icons into international markets. Since then, many contemporary athletes have sought commercial endorsement as a pot of gold that is much more lucrative and potentially enduring than the profits achieved from their respective sports. The question that brings Serena Williams and LeBron James together in this analysis is this: Why have these two highly accomplished, game-altering athletes been uneasy figures to iconicize within familiar narratives of rabid fandom, sports meritocracy, and racial inclusion? Williams and James

signify beyond the strictures of racial, sexual, gender, and market economies in professional athletics. They are not the first black athletes to be known for their exceptional athletic skills and competitive drive—their ability to win even under public scrutiny and critique. Yet their iconic status balances precariously on the pillars of their mastery of their respective sports and a public sentiment of racial resentment toward both because of their seeming unwillingness (at times) to perform an accommodating, conciliatory posture, a gratitude for their stardom. Instead, both embrace sheer domination, physical prowess, and a sense of racial and self possession that can cause great unease to many non-black audiences. Especially for Serena Williams, the sense of resentment and ambivalence from the sports world takes place on an international stage and in front of often hostile white audiences in many countries.

## LeBron James: The Making, Unmaking, and Remaking of a Black Sports Icon

The cultural and economic capital that Michael Jordan accrued as a corporatized sports icon has heightened the stakes of a niche industry in sports recruitment and journalism with speculation of the next "great black hope." There is not a more striking case of this anticipation than the media buzz generated around LeBron James years before he was even eligible to play in the NBA. When James was a young teenager in high school, his basketball team received more national attention than many college teams. For many in the sports industry, he was clearly the heir apparent to Jordan.

Nike's "We Are All Witnesses" campaign was a visually striking, oversized banner series meant to create, document, and generate an audience for a twenty-first-century corporatized sports icon: LeBron James. The site-specific advertisement located him in his hometown, in rust belt, underemployed,

and racially polarized northeastern Ohio. The multistory photographic banner hung high on the side of a downtown building in postindustrial Cleveland; it was epic in size and as a statement of athletic greatness. One image from the campaign centers James's torso, his arms outstretched and fingers reaching to the ends of the photographic frame. His face is tilted upward. He reaches toward what is unattainable for those who follow him. The Nike campaign is one of hyperbolic proportion, as was much of the public speculation and anticipation of James's greatness. The messianic scale by which Nike and the sports industry measured him was even more crystallized in a television campaign in which the young athlete plays hoops in a black church while a choir sings of his glory and majesty. To further both his coronation and deification, he was nicknamed "King James."

James was given the herculean task not only of saving the NBA in the post–Michael Jordan era but also of reviving the city of Cleveland, which for decades has endured high rates of unemployment, incarceration, legalized racism, and poverty. He was considered a hometown hero, having grown up in nearby Akron. Raised by a young single mother who struggled to care for him and at one time sent him to live with his coach, James's much-anticipated rise to greatness would be the mimetic path that the city used to remake itself. Thus LeBron James and the "We Are All Witnesses" campaign became the public face of Cleveland.

Curiously, as commercial audiences and sports fans partook in a coronation of the young athlete as the second coming, Jordan actually eschewed James as his heir and distanced himself from such comparisons. In public comments, Jordan was quick to diminish the talents of James; instead, he publicly ruminated and favored other players over James. This might partly be attributed to James's modest beginnings, a poor child raised by a single parent, whereas Jordan was raised in

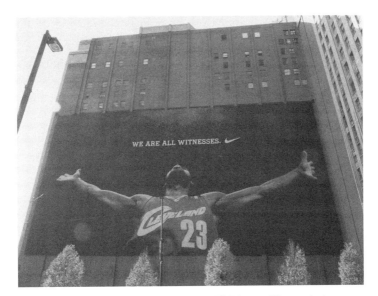

Figure 22.  LeBron James's Nike ad: "We Are All Witnesses" banner in down-town Cleveland. Photo Alex Abboud, 2009.

a middle-class, two-parent family with a strong father figure. In essence, James was the audience to whom Jordan as commercial and sports icon most appealed. When the young James entered the league in 2003, he chose to wear a jersey with the number twenty-three in honor of Jordan, who wore that number throughout his career. Later, James would change his number after routinely being snubbed by the retired athlete.

While the stereotype that the NBA is composed of black men who grew up in poor urban environments persists, recent data indicate that most professional basketball players are from higher socioeconomic backgrounds and are raised in more affluent neighborhoods than their black male peers. In other words, James is actually an anomaly within the contemporary NBA. Economist Seth Stephens-Davidowitz's analyzes:

> After winning his second N.B.A. championship last June, Mr. James was interviewed on television. He said: "I'm

LeBron James. From Akron, Ohio. From the inner city. I am not even supposed to be here." Twitter and other social networks erupted with criticism. How could such a supremely gifted person, identified from an absurdly young age as the future of basketball, claim to be an underdog? The more I look at the data, the more it becomes clear that Mr. James's accomplishments are more exceptional than they appear to be at first. Anyone from a difficult environment, no matter his athletic prowess, has the odds stacked against him.[12]

From 2003 until 2010, James led the Cleveland Cavaliers—a franchise with one of the longest losing records in the NBA—to its most successful era in the team's history with sold-out games, sought-after merchandise, and winning records. And during this period, he was without a doubt the most venerated figure in Ohio and many other NBA markets.

Yet this fairytale turnaround shifted dramatically in 2010, when James became a free agent and publicly courted many high-profile teams and cities during the off-season. His free-agency dance was not a topic confined to sports buffs and regional fans. Instead, it became a national media event that dramatized black iconicity and the precarious relationship between the black icon and a national public invested in maintaining a narrative of black athletic talent and white benevolent sports owners. The media frenzy over James's free agency and the hot pursuit by teams across the country led to an outsize national debate over whether the superstar basketball player would re-sign with the Cleveland Cavaliers or would "abandon" the team and the city that most needed him.

The media production of the momentous event, titled *The Decision*, now resonates as part of ongoing white public resentment toward highly paid black athletes like James. During this live event aired on ESPN, sports journalists, the NBA, James, and his agents turned his career decision into a suspenseful

televised bonanza. *The Decision* was set at the Boys and Girls Club in Greenwich, Connecticut, and the commercial proceeds from the event were donated to the nonprofit Boys and Girls Club of America. Nonetheless, the television show appeared less like a charitable event and more like a high-stakes business deal with millions of investors (from sports professionals to the watching public). James kept everyone in suspense about his basketball future and only revealed his decision in front of a live audience—shocking sports fans around the country when he decided to join the Miami Heat. Literally, within seconds of his announcement, it was clear that James's choice was unpopular among his fans, the city of Cleveland, the Cavaliers franchise, and many sportswriters. There was an immediate backlash, which James was unprepared to handle in front of a live audience.

What I find most affective about the event—both James's telecast decision and the pursuant uproar and demonization of him—was the moment on live TV when sports journalist and host Jim Gray directed James's attention to a monitor with a feed showing fans in Cleveland violently reacting to his decision. In one scene, a group of men curse the NBA star as they set fire to his memorabilia—his iconography. This is an unprecedented moment in the history of icons, racial or otherwise. For in this televisual instance, part of the icon-making machine—sports journalism—arranged a moment in which a real, flesh-and-blood human who has been transformed into venerated, redemptive sports icon is asked to witness the undoing of his image. In that moment when the journalist asked James to bear witness to live footage of fans burning pictures of him and his Cavaliers jersey, his voice cracked as he attempted to compose a response to the violent spectacle of his undoing as sports hero. James's pain and disappointment were palpable in those uneasy seconds of live television. I, as part of the audience, held my breath too in shock and discomfort at how

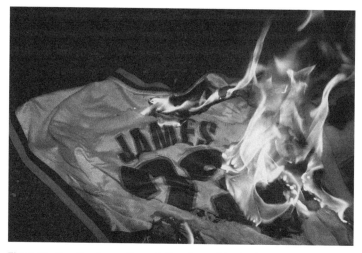

Figure 23. Cavaliers fans set fire to LeBron James Cleveland Cavaliers jerseys after James announced he was signing with the Miami Heat on July 8, 2010, in Akron, Ohio, at Dante's Gameday Grille. Photo Phil Masturzo / *Akron Beacon Journal.*

quickly the racial icon can become vulnerable and disregarded when her or his actions do not garner dominant public support. For days afterward, the sports public participated in and witnessed across print, radio, and televised media not only the workings of fandom but also the affective investment in the icon and what transpires when the icon fails to live up to our expectations and emotional investment.

Deepening the wound for James and further undoing his image was a highly emotional and racially tinged letter penned by the Cavaliers' owner and his former boss, Dan Gilbert. In it, Gilbert criticizes James for his "cowardly betrayal," lashing out:

> As you now know, our former hero, who grew up in the very region that he deserted this evening, is no longer a Cleveland Cavalier.
>
> This was announced with a several-day, narcissistic, self-promotional build-up culminating with a national TV special

of his "decision" unlike anything ever "witnessed" in the history of sports and probably the history of entertainment.[13]

Gilbert's letter laid the weight of racial iconicity on the shoulders of the singular black athlete. It absolved all the corporate interests, including his own, in creating and profiting from the corporatized black sports icon. Moreover, the venomous and denigrating tone of his words conveyed both the visceral attachment to the black icon and the claim to ownership that many whites still make to black bodies and destinies.

Outside the realm of sports fandom, various media critics and casual viewers of sports have had a range of responses, from "Who cares? He's a rich, spoiled athlete" to "He should not have chosen to create a live nationally televised event to essentially announce a career decision" to "What he did was awful to the city of Cleveland. He's so arrogant." Some have commented on how racialized the event became and what many perceived as the racial overtones of the Cavaliers' president's vitriolic response to James's decision.[14]

While many still express anger toward or dislike of James as a result of this decision and the way it became a media spectacle, for the most part, sentiments have faded with time and with the successes of his then chosen team, the Miami Heat. Yet his image as an exceptionally talented and highly paid sports icon has moved beyond the surface effect of campaigns like "We Are All Witnesses." Gone is the assumption that everyone cares about or endorses his prowess. One of the responses to this unraveling of the icon in visual culture and public discourse has been a series of Nike advertisements where James deliberates on himself as an iconic figure and the racial/visual paradox of being knowable in the most overdetermined ways and yet unknowable or controllable as icon and sign.

After joining the Miami Heat and weathering the anger and backlash that his decision inspired, James claimed a more

emboldened sense of agency and self-determination. In an era in which professional athletes are discouraged from taking political stances or making statements on topics considered controversial or polarizing, he took several actions to condemn racism in American society and within professional sports. His vocal stances on racial injustice have made him a leader among other professional athletes. One instance that garnered a great deal of public attention was in March 2012, one month after Trayvon Martin's death, when James posted on his Twitter account a photograph of the Miami Heat team in hooded jerseys with their heads bowed to show support for Martin's family. The message from his @KingJames account read, "#WeAreTrayvonMartin #Hoodies #Stereotyped #WeWantJustice."

In 2014, when tapes of then Los Angeles Clippers owner Donald Sterling making racist comments against blacks were released, James issued a public statement calling Sterling's comments "appalling" and asserting, "There's no room for Donald Sterling in the NBA—there is no room for him."[15] James told league executives that he would lead a player boycott if Sterling was not banned from the league in a timely manner. He reportedly told an NBA official that he would not play in the NBA if Sterling remained an owner.[16] Through these actions, James challenged the power imbalance between black players and white owners.

And yet in another surprising and clear example of James's sense of self-determination and agency, he shocked the sports world again when four years after *The Decision* and after two NBA championships with the Miami Heat, he decided to return to the Cleveland Cavaliers, the site of his dethroning (quite literally). James was careful not to announce *this* decision as a live media event and instead revealed it through print media—a less spectacular and instantaneous form in the contemporary media landscape. The *Cleveland Plain Dealer* ran an image of James in a Cavaliers uniform with his arms stretched above his head and

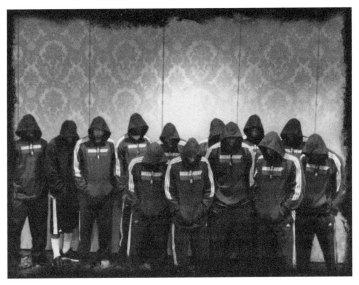

Figure 24. The Miami Heat in solidarity with the family of Trayvon Martin, 2012.

his eyes toward a heavenly light with the word *home* in large letters. A quotation above his head reads: "In Northeast Ohio, nothing is given. Everything is earned. You work for what you have. I'm ready to accept the challenge. I'm coming home."[17] In these words are a claim of a blue-collar work ethic that speaks to local constituents and an inferred apology. James's statement of his now readiness takes up "the challenge." While the media frenzy was not nearly as heightened as in 2010, one question that circulated loudly and publicly was how James could play for Gilbert, still the Cavaliers' owner, after Gilbert had published such a harsh and disdainful letter four years earlier. James addresses this issue in an essay published by *Sports Illustrated* called "I'm Coming Home":

> I always believed that I'd return to Cleveland and finish my career there. . . .
>
> To make the move I needed the support of my wife and my mom, who can be very tough. The letter from Dan

Gilbert, the booing of the Cleveland fans, the jerseys being burned—seeing all that was hard for them. My emotions were more mixed. It was easy to say, "OK, I don't want to deal with these people ever again." But then you think about the other side. What if I were a kid who looked up to an athlete, and that athlete made me want to do better in my own life, and then he left? How would I react? I've met with Dan, face-to-face, man-to-man. We've talked it out. Everybody makes mistakes. I've made mistakes as well. Who am I to hold a grudge?[18]

## THE FORCE OF SERENA WILLIAMS

While I pair Serena Williams with LeBron James, there are important distinctions between their careers and their respective sports and between the ways in which athletic power, body, and sexuality are read for black female athletes and black male athletes. In the last quarter of the twentieth century, basketball became associated with urban life and black masculinity in a way that no other sport has; in fact, the NBA has the highest percentage of black players of all major sports. Tennis, by contrast, is an individual sport that has historically been associated with the leisure and genteel classes, private clubs, and racial exclusivity. For tennis, training tends to be expensive and often takes place in exclusive facilities, many of which historically excluded blacks. The type of journalistic and media coverage and corporate sponsorships that these sports receive are also drastically different. Compared to most other professional sports, the culture of tennis undoubtedly produces very different conventions of dress, etiquette, and demeanor. Historically, it has been a sport played by the elite for elite fans.

Before the rise of the Williams sisters, Althea Gibson and Arthur Ashe were two notable black American players who achieved success and recognition in tennis.[19] Both are

remarkable for mapping paths for other blacks in professional tennis. Gibson's and Ashe's playing styles and on-the-court dress were much more in line with tennis's convention than the Williams sisters' are of generations later. Venus and Serena, who were raised in Compton, California, in the 1980s before moving to Florida to further their training, began playing tennis as young girls with their father as their coach. The parents, more so than the daughters, have spoken about the challenges that the girls endured as teens because of their racial and class differences from the majority of participants in tennis schools and tournaments. As is generally known, Serena Williams is not the first Williams sister to rise to national and international attention due to her tennis skills. Venus, the older of the sisters, entered professional tennis one year earlier than Serena, in 1994. Yet, not long after, Serena turned professional, and in 1999 she won her first Grand Slam title at the U.S. Open. By 2002, Serena claimed the number one ranking by the Women's Tennis Association, winning the French Open, the U.S. Open, and Wimbledon that year.

The Williams sisters' role in tennis highlights how sports, race, and convention work together to buttress ideals of gendered physicality, racialized femininity, and performative aesthetics. The sisters' ambivalent reception in the sporting world also uncovers a serious divide in how race, gender, and physical prowess are perceived by black fans of the sisters and the majority of white sports journalists and tennis fans. From very early in the sisters' careers, journalists and critics made comments on their clothing and hairstyles (especially the signature braids and beads of their teenage years) as much as on their aggressive playing style. In particular, Serena Williams's fashion choices on and off the court have been read as an explicit signification of difference. Even more, her sense of style has called forth a rehearsed and familiar response to what is perceived as racial excess, specifically the black female

body as excess. Together, Williams's style of playing tennis, her "grunting," the musculature of her body, and her clothing produce affective responses that play into polarized discourses where such choices are embraced by many of her black and progressive fans while questioned by the normative American public as markers of the black figure's unwillingness, or even inability, to conform to American and European conventions of sporting, femininity, and social cues. The unflinching boldness of the Williams sisters as tennis players and fashion icons and always as black American women is a challenge as much to the racial exclusivity of the game as to its class privilege, which the culture of tennis naturalizes.

On the most rudimentary and material levels, Serena Williams has defied tennis conventions by playing in attire that has veered from the standards of female tennis outfits. Traditionally, women's tennis gear has been restrained and dainty, color coordinated, and flirtatious, but not overtly sexual. The flare of the skirt suggests more than it reveals. Women's tennis attire in its feminine constraint and design is also a signal of the leisure and upper-class inflections of the sport: outfits that are not suited for labor or much more than playing tennis. From the beginning of their careers, Venus and Serena Williams moved away from the conventions of tennis fashion and incorporated bolder colors, a variety of fabrics and patterns, and urban and black accessories. Although my focus is on Serena here, it is important to note that her choices are in alignment with her sister's, as well as their training and coaching by her parents.

Instead of attempting to conform or "fit in" to tennis's racialized and gendered propriety, Serena Williams has used fashion and athletic technique to further distinguish herself from her white counterparts. One could argue that she embraces and plays with the discourse of excess through which her body and athletic performance are understood. For example, she has done publicity practice sessions in a neon pink body sheath; she

has won major titles in outfits accessorized with gold chains and large earrings, the accessories linked to urban black women's hip-hop style. On more than one occasion and before a live, televised audience, Williams has removed tennis skirts to finish matches in "booty shorts" that commentators respond to with gasps and not-so-silent pauses. With a sophisticated, yet not explicitly (at least verbally) articulated, understanding of how her body is interwoven with racial discourse, physical prowess, fashion, and sexuality, Williams not only performs to expectation but performs with such dominance and presence that she forces us to witness our investment in the signs that we employ to make sense of her athleticism and embodiment.

Undoubtedly her most discussed outfit/win came in 2002 when she donned a skintight black catsuit for the U.S. Open. About this sensational moment and performance, scholar Ramona Coleman-Bell writes:

> The attention given to Williams's catsuit is rooted in the wider historical imaginary of the black female body in the American public consciousness. The catsuit accentuates every curve in Williams's body, and images of her in such form-fitting gear often draw attention both to her breasts and her butt. In fact, many of the images of Williams's body that have circulated via magazines and internet sites have focused on her extremely fit, curvaceous physique. The catsuit, with its connotations of the feline huntress, and the repetition of sexualized and racialized iconography, works to draw attention to, and then displace, the fascination with Williams's hyper-encoded sexuality.[20]

Williams has also played the U.S. Open in a denim miniskirt, a black studded tank top, and knee-high boots. Williams prides herself on her role in designing and marketing her tennis outfits. Moreover, she has capitalized on her embrace of a style distinct from traditional tennis's codes and propriety

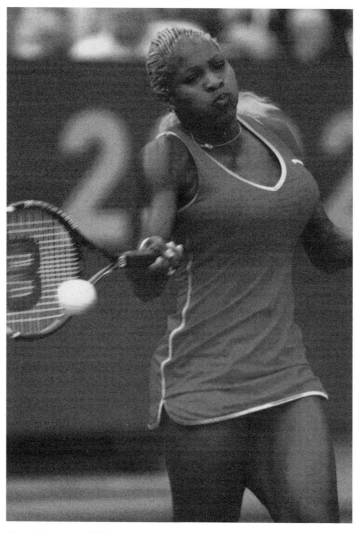

Figure 25. Serena Williams, U.S. Open, 2002. Photo Claudio Onorati / EPA.

by creating her own fashion line and partnering with Nike to market sporting apparel. (Before Nike, she partnered with Puma.)[21] At the same time, she has been charged with creating an "anything goes" atmosphere in women's tennis, where now more conventional white athletes experiment with color and style in ways that were previously unacceptable.[22]

The commentary on Williams's fashion are often subtle and not-so-subtle ways for sports commentators and fans to talk about her body—that which most explicitly sets her apart from the typical physique in women's tennis. She and her sister are noticeably taller than most contemporary women tennis players. Serena is also muscular and curvaceous in ways that set her apart from the typically lean and slender female form seen on the court. As cultural fixations, Serena Williams's garb and physique have garnered tremendous coverage in mass media—from sports writing to gossip columns to black lifestyle magazines—in a way that her taller, thinner, and more reserved sister has not. Serena's body is discussed as a site of controversy. At the same time, her body and size are routinely defended and celebrated by black and feminist scholars and cultural critics. Williams's relationship to her body and the commentary on it enacts a striking and powerful mode of embodied presence that demonstrates a deep awareness of her significance as an individuated subject, an exceptional athlete, and as part of a racialized and gendered collective, chosen or not.

Such embodied presence can be seen in Williams on the 2009 cover of "The Body Issue," *ESPN* magazine's inaugural issue. Positioned as an attempt to compete with *Sports Illustrated*'s highly popular annual swimsuit issue, *ESPN*'s magazine venture pulled in part from the same talent pool of *Sports Illustrated*; Williams had appeared in *Sports Illustrated*'s 2004 swimsuit issue. However, *ESPN*'s special issue distinguished itself by focusing on the athletic nude. On the cover of the issue featuring Williams, she is naked and smiling, accented by bright red lipstick.

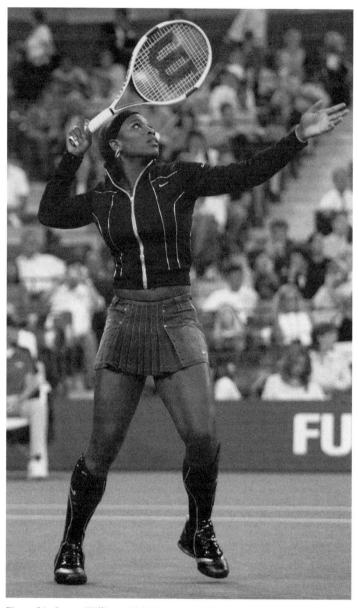

Figure 26. Serena Williams, U.S. Open, 2004. Photo Jason Szenes / EPA.

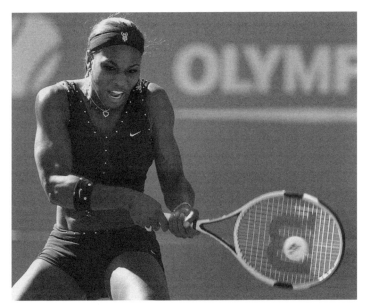

Figure 27. Serena Williams, U.S. Open, 2004. Photo Rhona Wise / EPA.

Her hand reaches to her ear, and her hair, typically pulled back in a ponytail or braided during matches, is flowing and straight here. The taut, defined muscles at work on the tennis court appear relaxed and supple. Williams is all curves. Inside the magazine, she poses in a black bikini. She teases and flirts, as she partially pulls down one side of her bikini bottom. In another image, she is photographed nude from behind, standing in shiny heels and holding a white bouquet at the center of her buttocks. To great success, the magazine chose a sensational body and a body that causes sensation in various sectors of media and public culture to launch this annual issue. To date, it is one of the best-selling issues in the magazine's history.

The focus on Williams's fashions and her body titillates and excites, but perhaps also distracts and masks the underlying threat that she and her sister pose to tennis and idealized white femininity. The Williams sisters have been dominant forces in

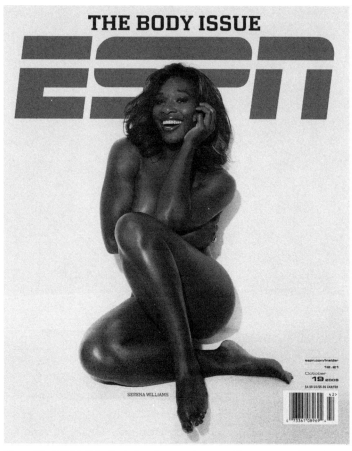

Figure 28. *ESPN,* "The Body Issue" cover: Serena Williams, 2009. Photo ©
2009, ESPN, Inc. Reprinted courtesy of ESPN.

tennis without making many public overtures to its white fan
base and while eschewing the sport's culture and aesthetics of
restraint, exclusivity, and entitlement. In an article proclaim-
ing Serena Williams the greatest American athlete of any sport
in a generation, journalist Ian Crouch writes:

> Forget tennis for a moment, though: when I say the greatest
> athlete in a generation, I mean the greatest in any sport. Sorry,

LeBron. Sorry, Tiger. Sorry, *Derek*. For fifteen years, over two generations of tennis, Williams has been a spectacular and constant yet oddly uncherished national treasure. She is wealthy and famous, but it seems that she should be more famous, the most famous. Anyone who likes sports should love Williams's dazzling combination of talent, persistence, style, unpredictability, poise, and outsized, heart-on-her-sleeve flaws.

But not everyone loves her. Part of this is owing to the duelling -isms of American prejudice, sexism, and racism, which manifest every time viewers, mostly men, are moved to remark on Williams's body in a way that reveals what might most charitably be called discomfort. What are they afraid of? The bodies of athletes, both male and female, are habitually on display, yet there has been something especially contentious and fraught about the ways in which Williams's singular appearance—musculature both imposing and graceful—has been discussed.[23]

The sisters have commented about their disappointment and pain at being booed on the court and after their victories in ways and situations that are racially inflected. While being known for their emotional responses to calls from referees and the results of their matches, they have performed a type of restrained humility and occasional surprise as they have racked up title after title. Their responses show a deep awareness of tennis's audiences and fan base and can be interpreted as attempts to mitigate their presence as threat. Yet, for both sisters, their championship titles and wealth are undeniable; Serena Williams is among the highest-paid female athletes in sports history. Even more, she has earned the highest prize money total in women's tennis history. At the age of thirty-two, in 2013, she won eleven titles.[24]

When Serena Williams won her sixth U.S. Open title (her third in row) on September 3, 2014, she entered a very

Figure 29. Serena Williams, French Open, 2013. Photo Caroline Blumberg / EPA.

exclusive club. She tied with Chris Evert and Martina Navratilova in having won eighteen Grand Slam single titles in women's tennis. Evert and Navratilova were there to congratulate Williams and present her with a Tiffany bracelet. During this event, there were active attempts by media commentators and sports pundits to incorporate explicitly her signs of difference. The features that had long served as sources of critique and ambivalence—her fashion, her "passion" and brashness (but not her body)—were now discussed as part of the package. This, I venture to say, is because Williams made it very clear that as much as some wish that she were not a dominant force in tennis, her presence will not and cannot be erased.

As the on-air celebration wrapped up, a female journalist turned to Serena and asked: "Before I let you go, you've been such a trendsetter. [*Points to her dress.*] It's called Fierce?" Serena responds with a big smile: "It's called 'Fierce.' It's a fierce dress. We decided to move away from solids for the year. Like I said at the beginning of the match, 'Roar.'" While journalists chatted and joked with her about her new fashion line, seamlessly

interspersed with her recent challenges and that day's historic victory, no one mentioned her elaborately painted fingernails, and in particular her middle finger—painted differently than the rest with sparkles on it. Here was her mark—both a directive, a pointing to her presence and the future, and a "fuck you" to all who have denied the force of her presence for over fifteen years of professional athletics.

Serena Williams and LeBron James are two players who make no concessions or apologies about their sense of self possession and determination, as well as their athletic prowess in the form of "mastery" and "domination" over their opponents. They claim a corporate appeal—with many sponsorships— and yet do not explicitly attempt to placate white fans and audiences. In fact, one of their shared characteristics is their unabashed ambition and ability to dominate their respective sports without mitigating the threat of their blackness, intelligence, and physical prowess to appease white patronage or hierarchies. Thus they are extremely profitable to the white corporate power structures and yet physically dominant and athletically superior threats to it as well.

Williams and James inherit the stigma and achievement of previous black athletes who became national and racial icons. But they have also forged new paths in sports, branding, and fashion, creating media sensation and controversy at nearly every turn. The stories of Johnson, Robeson, Carlos, and Smith are rife with the psychic costs of their exceptionalism and concomitant state scrutiny. Even Jordan's troubled personal and familial life has become media fodder, while he remains an iconic and wealthy sports businessman via his athletic line and corporate endorsements and as majority owner of the Charlotte Bobcats basketball team. Williams and James are still living and playing (with) their iconicity, their racial meanings unfolding in our increasingly corporatized and digitized lives as sports fans.

Race, competition, and temporality come to the fore as we wrestle with our obsession with sports icons who achieve and do with their bodies what we cannot with our own. They literally embody the human body pushed to new levels of discipline, power, and achievement. These performances become that much more potent and visceral when executed by a black American because of the logic of racial inequality and subjugation, which continue to shape our national and collective psyche. Sports focus our attention on the performance of the body as it expends a masterly, skilled burst of energy. Professional sports and their commoditization of the black athletic body also bring us face-to-face with the psychic and physical violence of the racial state that continually attempts to dominate and manipulate black bodies.

# *Coda*

THROUGHOUT THIS BOOK, I have considered the significance of black icons and racial iconicity in various sectors of American public life: politics, sports, popular music, and celebrity culture. As examined through various examples, the racial icon occupies a special place in the nation's imaginary as a figuration and negotiation of U.S. racial history, the democratic promise of "our country," and the ongoing struggles against racial injustice. Racial iconicity has served as a vibrational force—an affective energy—that leads to our valuation of the people we venerate and the devaluation of the lives of many others.

The icon functions in relation to the polis (as in citizenry, the citadel, governance) as national public and counterpublics continue to define, debate, imagine, memorialize, and canonize its historical legacy. The importance of photography and other media to producing and circulating racial icons and the interplay between the singularity of the icon and the collective and divergent responses to racial iconicity have animated the various examples discussed throughout this investigation. Yet the relationship between racial iconicity and racial precarity—the many ways that blacks are rendered vulnerable by racialization—is a crucial issue that haunts this study, and black life. This haunting takes shape in the charged chasm between iconic black celebrity and martyrdom, and between the celebration and vilification of both in the media, among different

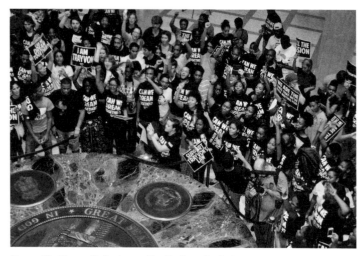

Figure 30. Dream Defenders at Florida State Capitol, 2013.

American publics and through the (dis)investment of capital. Black vulnerability—as a pronounced product and effect of the racial state that devalues most black life and iconizes a few is a deeply felt and shared, yet difficult to articulate, space whose gravity and orbit far exceed this project. The ability to be wounded or murdered because of one's racialization, its likelihood and shattering consequences, is in and of itself a recurring wound, a collective inheritance, the keloid of a society built on racial exploitation, violence, and genocidal annihilation.

Nowhere are the tensions between black iconicity and the devaluation of black life in modern American society experienced more than in the nation's unconscionable treatment of black children and youth. Their systemic abuse, neglect, and criminalization is, to me, one of the greatest tragedies of American democracy. If the icon acts as a beacon—and an assurance that one's sacrifices have meaning in a far grander scheme, then what do we make of the vexed representation of black youth in American public culture? Much of the significance and currency attributed to blackness in American public

culture can be attributed to the generative power of black youth. In each case study presented in the previous chapters, we see the workings of young, black people to create modes of self-determination within a system of meaning that swings between veneration and denigration: the selfie of Trayvon Martin that searches for recognition, the dreams and imaginings of (young) black activists that black political leadership will lead to racial justice, the young entertainers of Motown working to cultivate a sound and image that will lead to their entrance into the highest reaches of pop superstardom, and the sheer determination and performance of black youth in sports to be measured by the same standards and allowed access. Black youth have transformed this nation and fuel much of the significance that gets placed on the racial icon.

And yet, how have black youth, as a social category, been demonized and denigrated as the antithesis of democracy's promise and American progress? Black cultural scholars have long pointed out the juxtaposition between the criminalization of young, black men and boys and their romanticization, in the envy and co-optation of their fashion styles, athletic performance, and musical skills. This well-worn trope grows more familiar, and no less trenchant, with the continuous, dare I say quotidian and state-sanctioned, murders of unarmed black youth. In the period of writing this book, the murders of these unarmed black youth made national news: Trayvon Martin, Jordan Davis, Renisha McBride, and Michael Brown. What of those whose unjust and state-sanctioned deaths never circulate beyond their local communities and grieving loved ones?

The American public practices a tragic and willful forgetting of the sacrifices and commitment that black youth en masse have shown to social justice and political change. Their labor, bodies, and visions have laid the foundation for many of the gains of the civil rights era, the development and wealth of black entertainment culture, and the progressive shifts in

everyday race relations. Scholars of American culture, race, and ethnicity have examined the ways in which mainstream American society has benefited culturally and economically from the contributions of black youths (notably in popular music, sports, fashion, style, urban arts, and vernacular language). But the story that has yet to be fully explored is black youth's contribution to American politics and democracy.[1] Does the icon—in its singular grandeur—obfuscate the contribution of black youth to American democracy and public culture?

As a nation, we are well aware of the contribution that black youth have made through military service—conscripted and voluntary—throughout the long and bloody twentieth century and into the twenty-first century. But even more critical is their work in civil rights and justice struggles domestically. Whereas black youth have been characterized in public culture and mainstream media as politically apathetic nonvoters and disaffected noncontributors, black youth in fact have been one of the most active and vocal populations in the long struggle against racial injustice. The rarely celebrated story of the struggle for racial equality is the significance of black young people to changing American history. Black youth put their bodies on the line at segregated lunch counters and rode buses through Jim Crow territory. These youth were spat upon as they entered public schools that historically excluded them.

Photographic archives of the 1950s and 1960s are rife with images of the collective labor, optimism, and fearless actions of black youth who fought to build a more equal, more just future. Some notable examples are the Children's Crusade of 1963 and the many national and local protests of the National Association for the Advancement of Colored People (NAACP) Youth Council, such as the youth council's well-documented activism against police brutality in Milwaukee in the 1960s. We know of such moments largely

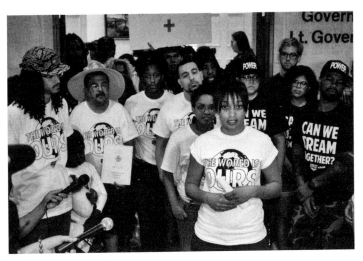

Figure 31. Dream Defenders at Florida State Capitol, 2013.

because they were photographed, and these photos became iconic; but the fact that in many cases these were youthful bodies—black children and teenagers—needs to be fully considered and cherished.

Fifty years later, new collectives of black youth and their allies have adopted some of the organizational and visual media strategies of previous generations. In similar ways, they organize and mobilize to make visible and to protest the vulnerable life prospects of being young, black, and poor in this country. Recent campaigns in response to widely publicized and state-sanctioned killings of unarmed young black men—Trayvon Martin and Michael Brown—have revitalized black youth activism. In the weeks after George Zimmerman's acquittal for Martin's murder, a group of diverse youth, with a large constituency of young blacks and Latinos, took over the Florida State Capitol. The group called themselves Dream Defenders and stated their mission to

bring social change by training and organizing youth and students in nonviolent civil disobedience, civic engagement,

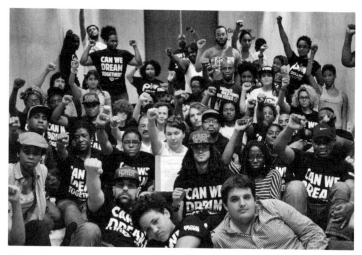

Figure 32. Dream Defenders at Florida State Capitol, 2013.

and direct action while creating a sustainable network of youth and student leaders to take action and create real change in their communities.

We fight the criminalization of our generation by directly confronting the sources, sponsors and supporters of it.

We defend the people's power to determine the destinies of our own communities.

We defend the right of all to a quality education and to live lives free of police brutality, racial profiling, and mass incarceration.

We defend the right of all to happiness with whomever they choose.

We believe that nonviolence, love, and unity will always triumph over racism and hate. We will not rest, until victory is won.[2]

With their focus centered on the present moment and by grounding their organizing in a rich history of black freedom struggles, the group poses a simple and provocative question about the future of the polis and the role of the icon: "Can we

dream together?" At rallies and gatherings, children, youth, and young adults sport T-shirts and hats and carry banners. The group has turned Martin Luther King's iconic speech into a collective query. The question also speaks to an earlier invitation made by the Student Nonviolent Coordinating Committee (SNCC) in a well-known poster campaign advocating for civil rights with "Come let us build a new world together." In the 1962 SNCC poster, the words are spread across three young black activists—two young adult men and a young girl—bowing in prayer. Leigh Raiford writes about this image and the strategic use of photography by SNCC: "The text accompanying the image provides an open invitation and an opportunity, a call to action. Here, the juxtaposition of words and image functions as a catalyst to transform audiences into active participants, or at the very least distant and/or financial supporters."[3]

The Dream Defenders' leaders have acknowledged their admiration for Stokely Carmichael and the SNCC of the 1960s. As idealistic (and naive, in the eyes of some) the question "Can we dream together?" might seem, the group actually imagines a possibility that we—the mythic (i.e., the dreamed-up) American public—fail to consider fully. What becomes of our icons—those venerated as well as those denigrated, our outcasts—if we dream together in full recognition of our history and presence together?

Black youth organizing for a viable life, for recognition, took a much heavier tone in the aftermath of the killing of Michael Brown by a police officer in Ferguson, Missouri. In the summer of 2014—a summer in which news media ran story upon story of local, regional, and international violent crises—the story of the killing of Brown, an eighteen-year-old black teenager just weeks away from starting college, by white officer Darren Wilson made its way to the top of news reportage. The media interests and attention in covering

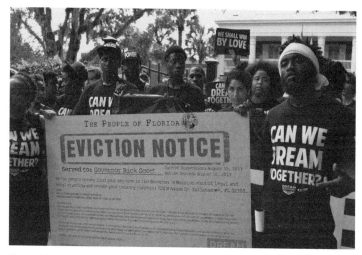

Figure 33. Dream Defenders Action Fund, delivering an eviction notice to Florida governor Rick Scott, August 2013.

Ferguson intensified when the local black community took to the streets, demanding answers and, more importantly, justice. About Brown's murder and the protests in Ferguson, Phillip B. Agnew of the Dream Defenders tweeted, "Our unwavering belief in this movement is based on a simple premise: we cannot un-see what we have seen . . . and there is a better way."[4]

Whereas President Obama and many other public figures aligned their fates with Trayvon Martin in the aftermath of Martin's killing, the president was unwilling to make such an alliance with Brown. Moreover, Obama distanced himself from the activism and demands for justice of the citizens of Ferguson and their many national and international allies. Obama was on vacation in Martha's Vineyard during the most intense protests where local police and officials routinely violated the residents' right to assemble. In many respects, Obama's reaction to Ferguson was akin to George W. Bush's response in 2005 to the deserted and desperate residents of New Orleans during and after Hurricane Katrina: the nonresponse, the evasion of

responsibility to a citizenry that is defined as outside of U.S. ideologies of proper citizenship. Instead, Obama sent Attorney General Eric Holder to Ferguson in hopes of quelling tensions, but without a clear directive for justice. Obama proved in his nonaction that his notion of being a president for "all Americans" means continuing the status quo in which the lives of blacks and the poor of all races are continually sacrificed for "the greater good," that is, a normative constituency primarily of whites but also of racialized minorities whose success and notions of security are based on ignoring or minimizing the extent of racial inequality or, even worse, for those who suffer at the hands of racial violence, blaming them for their fate.

In late fall 2014, after much pressure from various publics and media outlets to address highly public incidents of racial violence and police killings of black youth and men, Obama met with a group of young activists of color at the White House. Phillip B. Agnew of the Dream Defenders was among the group. Reflecting on the experience for the *Guardian*, Agnew wrote:

> We told President Obama that we were not the "People's Spokespeople." We told him that we had neither the power, positions, nor desires to stop the eruptions in the streets and that they would continue until a radical change happened in this country. We told him that we had no faith in anything, church or state. We told him that the country was on the brink and that nothing short of major capitulations at all levels of the government to the demands of the people could prevent it. Straight talk like that.
>
> We asked for the president to utilize his pulpit to spark the governmental culture shift that this movement calls for. We told him to end the Department of Defense's 1033 Program, to end federal funding to police departments with histories of discrimination, harassment, and murder. We

beseeched President Obama to invest in community-based alternatives to policing and incarceration and challenged him on the lack of data on the state's systematic and under-reported killings of unarmed black and Latino people.

He listened. Intently. He responded passionately. He agreed with many of our points and offered his take on the current State of the Union. He presented the reforms that have dominated the discourse in the hours after our meeting. He cautioned us against demanding too big and stressed gradualism. He counseled us that the wheels of progress turn sluggishly and reminded us of the progress that got us to this point: a room full of black folk in the Oval Office. He asked for our help, harkening back to his organizing days when, in the streets of Chicago, the cries of the people shifted the landscape. We debated on the power of the vote and the lack of faith in the Democratic party.

We did not budge.[5]

As a scholar, a mother, a black woman, what I find to be one of the biggest historical travesties is how we, as a society at large, have abandoned black youth when they have been some of the most fearless and committed in enacting much of the political, social, and cultural transformation of this nation. Residents of this nation—of all races—have benefited from the fearless political and cultural work of some of the most reviled of citizens. And what have we offered them? Instead of memorializing their significance in ending forms of legal racism, we criminalize, torture, neglect, and blame them for so many social ills. To date, George Zimmerman remains alive and free and the officer who shot and killed Michael Brown was not indicted for his death. More than anything, I wish that writing these words could change the conditions under which black children and youth live.

# Notes

## Introduction

1. The study benefits from important scholarship on race, gender, and visual culture by Tina Campt, Saidiya Hartman, bell hooks, John L. Jackson Jr., Kara Keeling, David Marriott, W. J. T. Mitchell, Jennifer Christine Nash, Leigh Raiford, Celine Parreñas Shimizu, Krista Thompson, Maurice O. Wallace, Michele Wallace, Deborah Willis, Ivy Wilson, and many others.

2. See *Encyclopedia of Fine Art*, s.v. "Icon Art," http://www.visual-arts-cork.com/painting/icons.htm.

3. See Lucia Chiavola Birnbaum, review of *The Black Madonna in Latin America and Europe*, by Malgorzata Oleszkiewicz-Peralba, *Catholic Historical Review* 94.4 (October 2008): 874.

4. W. J. T. Mitchell, *Iconology: Image, Text, Ideology* (Chicago: University of Chicago Press, 1986), 2.

5. See "On Language: Dark Words of Disapproval," *New York Times Magazine*, January 28, 1990, http://www.nytimes.com/1990/01/28/magazine/on-language-dark-words-of-disapproval.html.

6. Jennifer Roberts, "The Power of Patience: Teaching Students the Value of Deceleration and Immersive Attention," *Harvard Magazine*, November–December 2013, http://harvardmagazine.com/2013/11/the-power-of-patience.

7. Robert Hariman and John Louis Lucaites, *No Caption Needed: Iconic Photographs, Public Culture, and Liberal Democracy* (Chicago: University of Chicago Press, 2007), 27 (italicized in the original).

8. Ibid., 28.

9. W. J. T. Mitchell, *Seeing through Race* (Cambridge, MA: Harvard University Press, 2012), 13.

CHAPTER 1   "I AM TRAYVON MARTIN"

1. City of Sanford, Florida, "Transcript of George Zimmerman's Call to the Police," February 26, 2012, accessed through *Mother Jones*, http://www.motherjones.com/documents/326700-full-transcript-zimmerman (accessed July 4, 2014).

2. Florida Legislature, *Chapter 776: Justifiable Use of Force*, 2012 Florida Statutes, http://www.leg.state.fl.us/Statutes/index.cfm?App_mode=Display_Statute&URL=0700-0799/0776/0776ContentsIndex.html&StatuteYear=2012&Title=-%3E2012-%3EChapter%20776. Also see Audra D. S. Burch and Janey Tate, "Tapes Show Sanford Police Grew Skeptical of Zimmerman's Story," *Miami Herald*, June 21, 2012, http://www.miamiherald.com/2012/06/21/2860569/zimmerman-told-police-trayvon.html.

3. Matthew Pratt Guterl, *Seeing Race in Modern America* (Chapel Hill: University of North Carolina Press, 2013), 203–4.

4. See Robin D. G. Kelley, "The Riddle of the Zoot: Malcolm Little and Black Cultural Politics during World War II," in *Race Rebels: Culture, Politics, and the Black Working Class* (New York: Free Press, 1994); and Catherine Ramirez, "Crimes of Fashion: The Pachuca and Chicana Style Politics," *Meridians: feminism, race, transnationalism* 2.2 (2002): 1–35.

5. Matthew Hutson, "The Power of the Hoodie-Wearing C.E.O.," *Currency* (blog), *New Yorker*, December 23, 2013, http://www.newyorker.com/online/blogs/currency/2013/12/the-power-of-the-hoodie-wearing-ceo.html.

6. See my critique of racial iconicity in Nicole R. Fleetwood, *Troubling Vision: Performance, Visuality, and Blackness* (Chicago: University of Chicago Press, 2011).

7. See Maeve Duggan, "Photo and Video Sharing Grow Online," Pew Internet and American Life Project, October 28, 2013, http://pewinternet.org/Reports/2013/Photos-and-videos.aspx; and Cooper Smith, "Facebook Users Are Uploading 350 Million New Photos Each Day," *Business Insider*, September 18, 2013, http://www.businessinsider.com/facebook-350-million-photos-each-day-2013-9.

8. Stephanie Condon, "Obama: 'If I Had a Son, He'd Look like Trayvon,'" *CBS News*, March 23, 2012, http://www.cbsnews.com/news/obama-if-i-had-a-son-hed-look-like-trayvon.

9. Tom Cohen, "Obama: 'Trayvon Martin Could Have Been Me,'" *CNN*, July 19, 2013, http://www.cnn.com/2013/07/19/politics/obama-zimmerman.

10. William Bradford Huie, "The Shocking Story of Approved Killing in Mississippi," *Look*, January 24, 1956, 46–48, 50.

11. "People and Events: Mamie Till Mobley (1921–2003)," *The Murder of Emmett Till, American Experience*, PBS, 2003, http://www.pbs.org/wgbh/amex/till/peopleevents/p_parents.html.

12. Robin D. G. Kelley, "Spark for a New Generation," *The Murder of Emmett Till*, http://www.pbs.org/wgbh/amex/till/sfeature/sf_kelley_01.html.

13. Myisha Priest, "'The Nightmare Is Not Cured': Emmett Till and American Healing," *American Quarterly* 62.1 (March 2010): 3.

14. For example, Priest points to Till's "gouged eye, the haunting revenant" as "the predominate symbol" for memorializing him (ibid., 18).

15. Lizette Alvarez and Cara Buckley, "Zimmerman Is Acquitted in Trayvon Martin Killing," *New York Times*, July 13, 2013, http://www.nytimes.com/2013/07/14/us/george-zimmerman-verdict-trayvon-martin.html.

16. Robin D. G. Kelley, "The U.S. v. Trayvon Martin: How the System Worked," *Huffington Post*, July 15, 2013, http://www.huffingtonpost.com/robin-d-g-kelley/nra-stand-your-ground-trayvon-martin_b_3599843.html.

CHAPTER 2    DEMOCRACY'S PROMISE

1. "Ron English in Boston," *New England Journal of Aesthetic Research*, July 25, 2008, http://aesthetic.gregcookland.com/2008_07_20_archive.html.

2. Erica R. Edwards, "The Black President Hokum," *American Quarterly* 63.1 (March 2011): 34.

3. Ivy Wilson, *Specters of Democracy: Blackness and the Aesthetics of Politics in the Antebellum U.S.* (New York: Oxford University Press, 2011), 19.

4. Laura Wexler, "'A More Perfect Likeness': Frederick Douglass and the Image of the Nation," in *Pictures and Progress: Early Photography and the Making of African American Identity*, ed. Maurice O. Wallace and Shawn Michelle Smith (Durham, NC: Duke University Press, 2012), 18.

5. See Shawn Michelle Smith, *Photography on the Color Line: W. E. B. DuBois, Race, and Visual Culture* (Durham, NC: Duke University Press, 2004); Deborah Willis and Barbara Krauthamer, *Envisioning Emancipation: Black Americans at the End of Slavery* (Philadelphia: Temple University Press, 2012); and Deborah Willis, *Let Your Motto Be Resistance: African American Portraits* (Washington, DC: Smithsonian Books, 2007).

6. See Donna M. Wells, "Frederick Douglass and the Progress of Photography," *HUArchivesNet: The Electronic Journal MSRC–Howard University*, no. 3 (February 2000), http://www.huarchivesnet.howard.edu/0002huarnet/freddoug.htm.

7. Frederick Douglass, "Pictures and Progress," digital manuscript, Library of Congress, http://www.loc.gov/resource/mfd.28009/#seq-2.

8. Wallace and Smith, *Pictures and Progress*, 2–3.

9. Wexler, "'A More Perfect Likeness,'" 36.

10. Ginger Hill, "'Rightly Viewed': Theorizations of Self in Frederick Douglass's Lecture on Pictures," in Wallace and Smith, *Pictures and Progress*, 42.

11. Ibid.

12. See Leigh Raiford, *Imprisoned in a Luminous Glare: Photography and the African American Freedom Struggle* (Chapel Hill: University of North Carolina Press, 2011); and Martin A. Berger, *Seeing through Race: A Reinterpretation of Civil Rights Photography* (Berkeley: University of California Press, 2011).

13. Erica R. Edwards, *Charisma and the Fictions of Black Leadership* (Minneapolis: University of Minnesota Press, 2012), 111.

14. Raiford, *Imprisoned in a Luminous Glare*, 22.

15. Hortense Spillers, "Destiny's Child: Obama and Election '08," *boundary 2* 39.2 (2012): 8.

16. Ian Reifowitz, "Obama's Inequality Speech: Telling the Progressive Story of American History," *The Blog, Huffington Post*, December 6, 2013, http://www.huffingtonpost.com/ian-reifowitz/obamas-inequality-speech-_b_4394169.html.

17. Martin Luther King Jr., "I Have a Dream . . . ," March on Washington, August 28, 1963, Washington, DC, transcript, National Archives and Records Administration, http://www.archives.gov/press/exhibits/dream-speech.pdf.

18. "Remarks by the President on Economic Mobility," December 4, 2013, Washington, DC, U.S. Office of the Press Secretary, transcript, *Daily Kos*, http://www.dailykos.com/story/2013/12/04/1260116/-President-Obama-s-remarks-on-economic-mobility#.

19. For more on Shepard Fairey's *Hope* poster and related lawsuits, see Benjamin Weiser, "Shepard Fairey Pleads Guilty over Obama 'Hope' Image," *ArtsBeat* (blog), *New York Times*, February 24, 2012, http://artsbeat.blogs.nytimes.com/2012/02/24/shepard-fairey-pleads-guilty-over-obama-hope-image; David Ng, "Shepard Fairey Gets Two Years' Probation in Obama 'Hope' Poster Case," *Los Angeles Times*, September 7, 2012, http://articles.latimes.com/2012/sep/07/entertainment/la-et-cm-shepard-fairey-associated-press-obama-20120905; and Eriq Gardner, "Obama Administration Demands 'Hope' Artist Shepard Fairey Serve Prison Time," *Hollywood Reporter*, September 7, 2012, http://www.hollywoodreporter.com/thr-esq/obama-hope-poster-shepard-fairey-368668.

20. Santiago Lyon, "Obama's Orwellian Image Control," Opinion Pages, *New York Times*, December 11, 2013, http://www.nytimes.com/2013/12/12/opinion/obamas-orwellian-image-control.html.

21. In his second term, Obama has responded to racism and racially tinged national tragedies by invoking black publics to do more and try harder. This can be seen in the formation of the ini-

tiative My Brother's Keeper, meant to provide mentoring and resources to boys and young men of color. See My Brother's Keeper, http://www.whitehouse.gov/my-brothers-keeper#section-about-my-brothers-keeper.

CHAPTER 3    GIVING FACE

1. Throughout this chapter, I use feminine pronouns to talk about the icon broadly and in generic terms, though the icon is far from being generic.
2. For more on the history and rise of the celebrity in American culture, see Charles L. Ponce de Leon, *Self-Exposure: Human-Interest Journalism and the Emergence of Celebrity in America, 1890–1940* (Chapel Hill: University of North Carolina Press, 2002).
3. Leo Braudy, *The Frenzy of Renown: Fame and Its History* (New York: Oxford University Press, 1986), 589.
4. Su Holmes and Sean Redmond, "Introduction: Understanding Celebrity Culture," in *Framing Celebrity: New Directions in Celebrity Culture*, ed. Su Holmes and Sean Redmond (New York: Routledge, 2006), 3. Also see Anthony Elliott, *The Mourning of John Lennon* (Berkeley: University of California Press, 1999).
5. Karen Sternheimer, *Celebrity Culture and the American Dream: Stardom and Social Mobility* (New York: Routledge, 2011).
6. Adrienne Lai, "Glitter and Grain: Aura and Authenticity in the Celebrity Photographs of Juergen Teller," in Holmes and Redmond, *Framing Celebrity*, 215.
7. Nelson George, *Where Did Our Love Go? The Rise and Fall of the Motown Sound* (New York: St. Martin's Press, 1985; Urbana: University of Illinois Press, 2007), xiv.
8. Mark Anthony Neal, *What the Music Said: Black Popular Music and Black Public Culture* (New York: Routledge, 1998), 88.
9. Christian John Wikane, "Have Fun: A Tribute to Diana Ross, Nile Rodgers, and the CHIC Groove of 'diana' (Parts 1–4)," *PopMatters*, May 19, 2013, http://www.popmatters.com/feature/171654-have-fun-a-tribute-to-diana-ross-nile-rodgers-and-the-chic-groove-of.
10. Mary Wilson, *Dreamgirl: My Life as a Supreme*, with Patricia Romanowski and Ahrgus Julliard (New York: St. Martin's Press, 1986), 181.
11. Margalit Fox, "Maxine Powell, Motown's Maven of Style Dies at 98," *New York Times*, October 16, 2013.
12. George, *Where Did Our Love Go?*, 87.
13. Ibid., 88.
14. Richard Dyer, *Heavenly Bodies: Film Stars and Society*, 2nd ed. (Basingstoke, UK: Macmillan, 1986; London: Routledge, 2004); Dyer, *Stars*, new ed. (1979; London: British Film Institute, 1998).
15. Roland Barthes, *Mythologies*, trans. Annette Lavers, 25th printing (New York: Noonday Press, 1991).

16. Leo Braudy credits the attention to individuals' facial details as part of the evolution of Renaissance art and portraiture focusing on famous people of the era. See Braudy, "Printing and Portraiture," in *The Frenzy of Renown*.

17. Barthes, *Mythologies*, 56.

18. George, *Where Did Our Love Go?*, 142.

19. Quoted in Diana Ross, *Diana Ross: Going Back*, ed. Rosanne Shelnutt (New York: Universe Publishing, 2002), 13.

20. Angela Davis, "Afro Images: Politics, Fashion, and Nostalgia," *Critical Inquiry* 21.1 (Autumn 1994): 38.

21. Neal, *What the Music Said*, 89.

22. Sternheimer, *Celebrity Culture and the American Dream*, 3.

23. James Ingram quoted in Wikane, "Have Fun: A Tribute."

24. Diana Ross, *Secrets of a Sparrow* (London: Headline Book Publishing, 1993), 87.

25. Ross, *Diana Ross: Going Back*, 22.

26. Anne Anlin Cheng, *Second Skin: Josephine Baker and the Modern Surface* (New York: Oxford University Press, 2011), 39.

27. "New Day for Diana," *Life*, December 8, 1972, 42.

28. Ibid., 42–43.

29. Farah Griffin, *If You Can't Be Free, Be a Mystery* (New York: Ballantine Books, 2001).

## CHAPTER 4   THE BLACK ATHLETE

1. For more on the birth of modern celebrity, see Ponce de Leon, *Self-Exposure*.

2. Ibid., 71.

3. Harvey Young, *Embodying Black Experience: Stillness, Critical Memory, and the Black Body* (Ann Arbor: University of Michigan Press, 2010), 94.

4. Ibid., 95.

5. Theresa Runstedtler, *Jack Johnson, Rebel Sojourner: Boxing in the Shadow of the Global Color Line* (Berkeley: University of California Press, 2012), 134.

6. Young, *Black Experience*, 87.

7. Runstedtler, *Jack Johnson*, 253.

8. Hazel Carby, *Race Men* (Cambridge, MA: Harvard University Press, 1998), 48.

9. Ibid., 50.

10. One of the most well-documented politically active athletes, Ali was active and vocal in his support of movements against racial injustice and anti–Vietnam War activism. On April 28, 1967, Ali refused to be inducted in the military, citing religious beliefs as a practicing Muslim. For his refusal, he was convicted of draft evasion and punished by a banishment from boxing for three years: "Ali, who was convicted of draft evasion, took his legal battle all the way

to the U.S. Supreme Court, which in 1971 ruled in his favor." "As He Turns 70, Ali's Activist Legacy Endures," *CBS News*, January 12, 2012, http://www.cbsnews.com/news/as-he-turns-70-alis-activist-legacy-endures.

11. Norman K. Denzin, "Representing Michael," in *Michael Jordan, Inc.: Corporate Sport, Media Culture, and Late Modern America*, ed. David L. Andrews (Albany: State University of New York Press, 2001), 6.

12. Seth Stephens-Davidowitz, "In the N.B.A., ZIP Code Matters," Opinion Pages, *New York Times*, November 2, 2013, http://www.nytimes.com/2013/11/03/opinion/sunday/in-the-nba-zip-code-matters.html.

13. "Open Letter to Fans from Cavaliers Majority Owner Dan Gilbert," Official Site of the Cleveland Cavaliers, July 8, 2010, http://www.nba.com/cavaliers/news/gilbert_letter_100708.html.

14. See Robert Groves, "The Demonization of LeBron James," *Sports-Money* (blog), *Forbes*, June 16, 2011, http://www.forbes.com/sites/sportsmoney/2011/06/16/the-demonization-of-lebron-james.

15. "LeBron Says NBA Must Reject Sterling," ESPN.com, April 27, 2014, http://espn.go.com/nba/truehoop/miamiheat/story/_/id/10844906/lebron-james-no-room-donald-sterling-nba.

16. "LeBron James Said to Be Ready to Lead NBA Player Boycott over Donald Sterling," *CBS News*, May 14, 2014, http://www.cbsnews.com/news/lebron-james-said-ready-to-lead-nba-player-boycott-over-donald-sterling.

17. "Home," *Cleveland Plain Dealer*, special section, July 12, 2014.

18. LeBron James, "I'm Coming Home," with Lee Jenkins, SI.com, July 11, 2014, http://www.si.com/nba/2014/07/11/lebron-james-cleveland-cavaliers

19. See Cecil Harris and Larryette Kyle-DeBose, *Charging the Net: A History of Blacks in Tennis from Althea Gibson and Arthur Ashe to the Williams Sisters* (Chicago: Ivan R. Dee, 2007).

20. Ramona Coleman-Bell, "'Droppin' It like It's Hot': The Sporting Body of Serena Williams," in Holmes and Redmond, *Framing Celebrity*, 198.

21. See ibid., 195–205; and Julie Earle-Levine, "Serena Williams Making First Fashion Week Presentation," *New York Post*, September 6, 2014, http://nypost.com/2014/09/06/serena-williams-making-1st-fashion-week-presentation.

22. Tony Manfred, "The Most Outrageous Women's Outfits in U.S. Open History," *Business Insider*, August 29, 2011, http://www.businessinsider.com/us-open-oufits-2011-8.

23. Ian Crouch, "Serena Williams Is America's Greatest Athlete," *New Yorker*, September 9, 2014, http://www.newyorker.com/news/sporting-scene/serena-williams-americas-greatest-athlete.

24. Per Lijas, "Serena Williams Seals off Dominant Year with Eleventh Title," *Keeping Score* (blog), *Time*, October 28, 2013, http://keeping-

score.blogs.time.com/2013/10/28/serena-williams-seals-off-dominant-year-with-11th-title.

CODA

1. For more on black youth's contributions, see Cathy Cohen, *Democracy Remixed: Black Youth and the Future of American Politics* (New York: Oxford University Press, 2010); and Andreana Clay, *The Hip-Hop Generation Fights Back: Youth, Activism, and Post–Civil Rights Politics* (New York: New York University Press, 2012).
2. Dream Defenders, "Be the Power," http://dreamdefenders.org.
3. Leigh Raiford, "'Come Let Us Build a New World Together': SNCC and Photography of the Civil Rights Movement," *American Quarterly* 59.4 (December 2007): 1137.
4. Phillip B. Agnew, Twitter post, August 14, 2014, 11:27 a.m., http://twitter.com.philofdreams.
5. Phillip B. Agnew, "What President Obama Told Me about Ferguson's Movement: Think Big, but Go Gradual," *Guardian*, December 5, 2014, http://www.theguardian.com/commentisfree/2014/dec/05/obama-ferguson-movement-oval-office-meeting.

# About the Author

Nicole R. Fleetwood is the director of the Institute for Research on Women and an associate professor in the Department of American Studies at Rutgers University, New Brunswick. She researches and teaches in the areas of visual culture and media studies, black cultural studies, gender theory, and culture and technology studies. Her articles appear in *African American Review, American Quarterly, Callaloo: A Journal of African Diaspora Arts and Letters, Signs: Journal of Women in Culture and Society, Public Culture, Social Text, TDR: The Drama Review,* and edited anthologies. Her book *Troubling Vision: Performance, Visuality, and Blackness* (2011) is the recipient of the 2012 Lora Romero First Book Publication Prize of the American Studies Association.

Currently, she is completing a book on prison art and visuality, in which she examines a range of visual art forms and practices emerging inside prisons and about prison life, including photography, painting, and collaborative works with arts organizations and commissioned artists. As part of this research, she co-convened "Marking Time," an international conference and multisite exhibition on prison arts and activism, held at Rutgers University in October 2014.